POSTCARD HISTORY SERIES

Southwest Georgia

in Vintage Postcards

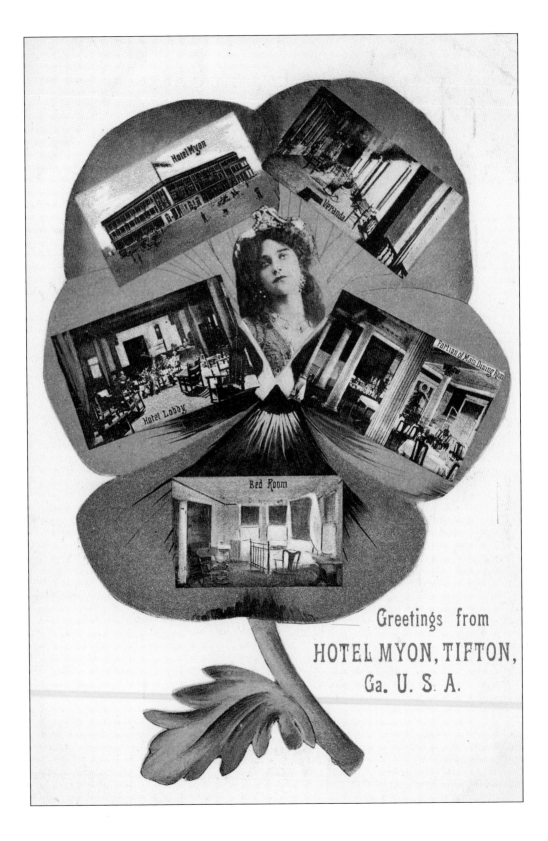

Hotel Myon

Veranda

Hotel Lobby

Portion of Main Dining Room

Bed Room

Greetings from
HOTEL MYON, TIFTON,
Ga. U. S. A.

POSTCARD HISTORY SERIES

Southwest Georgia
in Vintage Postcards

Gary L. Doster

ARCADIA
PUBLISHING

Published by Arcadia Publishing
Charleston SC, Chicago IL, Portsmouth NH, San Francisco CA

Printed in the United States of America

Library of Congress Catalog Card Number applied for.

For all general information contact Arcadia Publishing at:
Telephone 843-853-2070
Fax 843-853-0044
E-Mail sales@arcadiapublishing.com
For customer service and orders:
Toll-Free 1-888-313-2665

Visit us on the Internet at www.arcadiapublishing.com

For Faye Thomas Doster
A Good and Generous Person
to Whom I Owe So Much

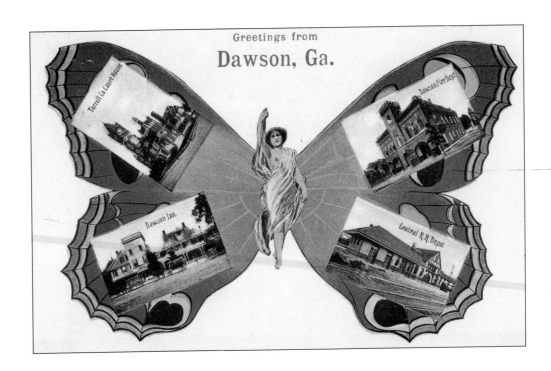

CONTENTS

ACKNOWLEDGMENTS

For help in various ways, including advice, information, and post cards, I wish to thank the following people:

Carl Anderson

Jim Dunn

Nell Dunn

Jerald Ledbetter

Ernest Malcom

Dan Marshall

Bill Moffat

Edwin Oldham

Hershel Reeves

Gordon Sanford

Bill Wheless

INTRODUCTION

We are indeed fortunate that post cards* were invented and were so popular during the first several years of this century. In the clamor to satisfy the almost overwhelming demand for more and more post cards by the public, literally thousands of scenes were photographed that were never captured on film for any other reason. Over time, many of the homes, depots, court houses, stores, and other buildings so pictured have disappeared and these early post card views are the only images that remain. Two particularly interesting facts that were discovered while selecting and compiling the cards for these books concerned Georgia's Confederate monuments. A great many monuments were unveiled or dedicated on Confederate Memorial Day, April 26, and few of them remain on their original sites. The ladies of the United Daughters of the Confederacy and the old veterans themselves usually selected some prominent spot in the middle of town, almost always at the intersection of two main streets. Invariably, as automobile use increased over years, the monuments became traffic hazards and were moved to another part of town. Consequently, many of these post card views are the only pictures of them in their original locations.

Also of great interest are the views showing the intrusion of the automobile onto the scene. It is fun to note that the earlier post card views, those before 1907 or 1908, usually have horse- or mule-drawn wagons, buggies, or carriages in the street scenes (a few even show mule-powered streetcars!). Then, from that time to about 1912 or 1914, these views will typically show a mix of the animal-drawn vehicles and early automobiles. After this time, a wagon or buggy is only rarely seen, and the number of automobiles on the streets increased rapidly.

The collecting frenzy that swept the world began in Europe in the 1890s,

*Throughout the book, I have chosen to use the older spelling of the word, i.e. "post card" versus "postcard."

crept into this country before the turn of the century, and erupted a few years later. Many of the better quality post cards were produced in Europe, particularly Germany. Some of the post card factories in Germany were the size of cotton mills in this country, and they employed hundreds of people. For example, one German plant in 1909 had 112 cylinder printing presses and employed 1,500 workers. During the peak years of the post card collecting fad, more than a million people in Germany were employed in the post card business. In the three-year period from 1907 to 1909, more than 85,000 tons of post cards were imported into the United States from Germany.

In the Images of America book series published by Arcadia, the major effort has been to render pictorial books on individual towns or counties. And these are wonderful. Those of us who have an interest in preserving whatever we can of our past are hungry for books like this and they serve a valuable purpose. However, there are hundreds of smaller communities across every state that offer only a limited number of views of life of yesteryear that also are striking and important. Some medium-sized towns may have a handful of good views that show what their community and its people looked like nearly one hundred years ago. Many of the very small towns may have only one or two representative views. All of these are important, but none of them can support a book alone. Hence, this series of six volumes was conceived to provide a vehicle whereby a collection of early Georgia post cards from numerous small communities could be exhibited.

It is important to note here that this set of books is not intended to be any sort of scholarly work. It is merely an attempt to provide access to a selection of early views of Georgia that are not available in any other form, most of which have not been reprinted since their original publication. Many of the captions we provide in these books are no more than the caption printed on the cards when they were produced. Some additions have been made to some cards when the author had knowledge of some facts regarding the view in question. Other information came from the few reference books listed in the bibliography. To have researched each view and provided a comprehensive caption for each would have taken a lifetime of research, and then would still have been incomplete.

The author is a lifelong Georgian and has collected all manner of Georgiana for most of his life. Some of his other collecting interests are obsolete currency from the Colonial period through the War between the States, early letters and other documents, slave bills of sale and other items pertaining to slavery, Confederate letters and documents, old photographs, trade tokens, and Native-American relics.

One

BROOKS, COLQUITT, AND THOMAS COUNTIES

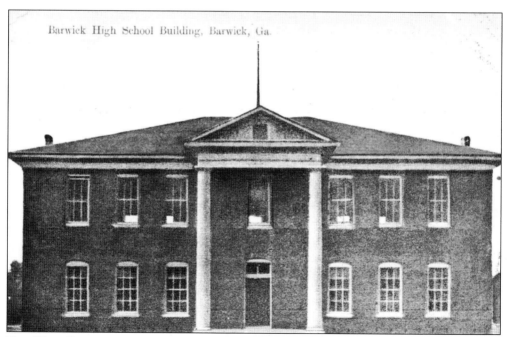

THE HIGH SCHOOL AT BARWICK, *C.* 1910.

THE SANCHEZ PRIVATE SANITARIUM IN BARWICK. Their printed message advised that this was a "modern, fully equipped hospital in a rich agricultural section of the state, famous for its hams, and was the leading watermelon section of the United States."

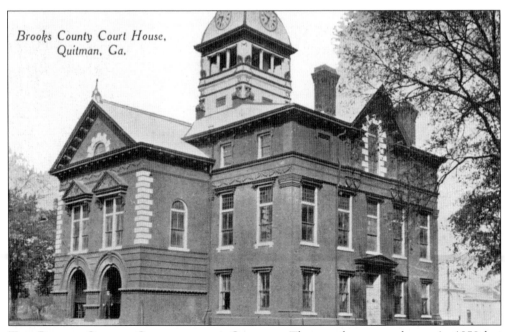

Brooks County Court House, Quitman, Ga.

THE BROOKS COUNTY COURTHOUSE IN QUITMAN. The courthouse was begun in 1859 but not completed until 1864, near the end of the War between the States. The building underwent extensive renovation in 1892 and 1893.

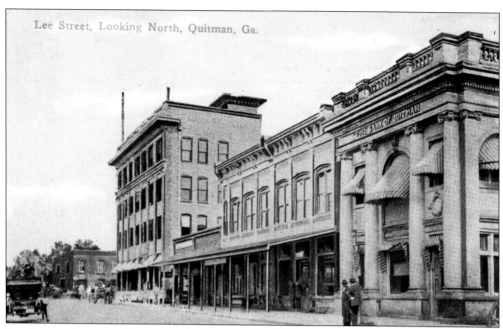

Lee Street Looking North in Quitman, *c.* **1913.** The Bank of Quitman, with J.O. Morton as president, was located on the corner.

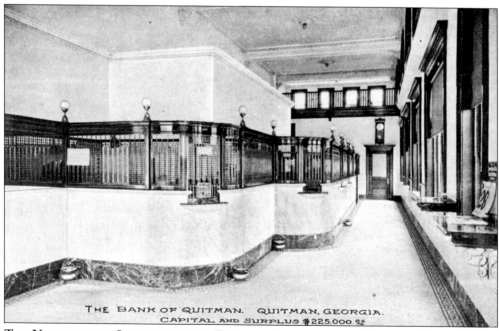

The Neat-looking Interior of the Bank of Quitman with a Printed Message that Boasted of $225,000 Capital and Surplus.

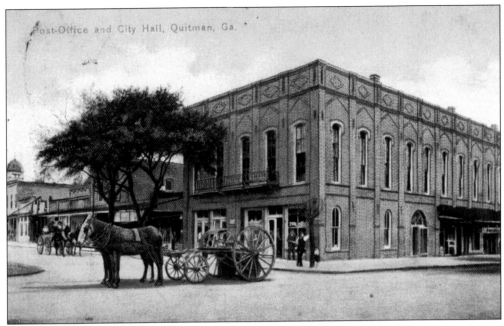

THE POST OFFICE AND CITY HALL AT QUITMAN IN 1907.

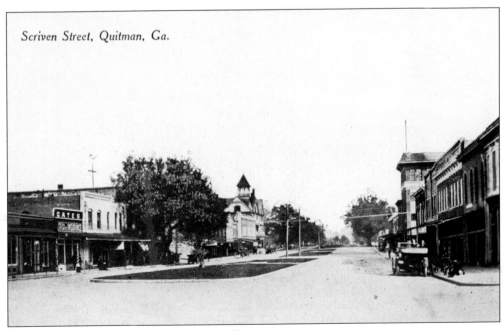

A *c.* 1910 VIEW OF A SCRIVEN STREET IN QUITMAN.

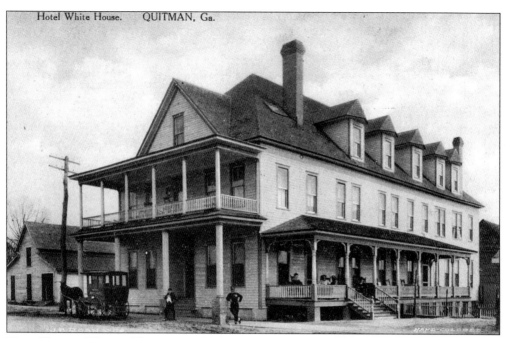

THE HOTEL WHITE HOUSE IN QUITMAN. The hotel featured a nice large porch for upstairs guests.

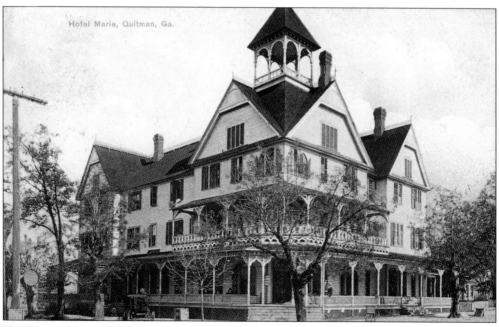

THE HOTEL MARIE IN DOWNTOWN QUITMAN. The hotel claimed to be "Home of the Transient." W.J. Powell was the proprietor and rates were $2 and $2.50 per day.

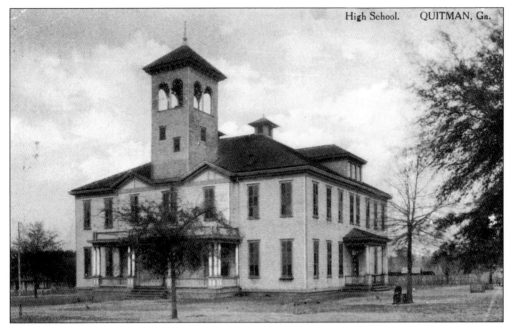

High School. QUITMAN, Ga.

THE HIGH SCHOOL AT QUITMAN, *C.* 1910.

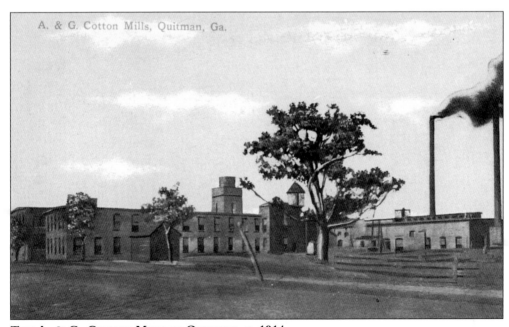

A. & G. Cotton Mills, Quitman, Ga.

THE A. & G. COTTON MILLS IN QUITMAN, *C.* 1914.

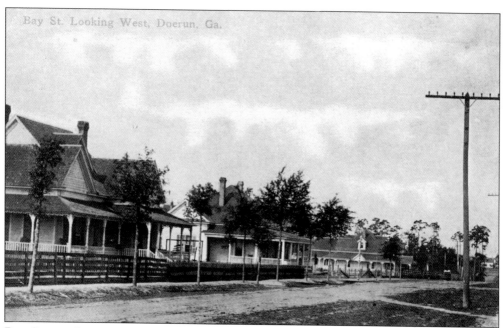

BAY STREET LOOKING WEST IN DOERUN, C. 1912.

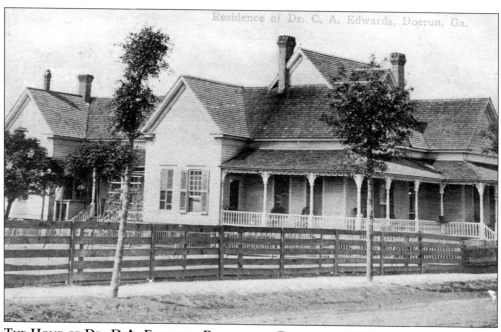

THE HOME OF DR. D.A. EDWARDS, PHYSICIAN IN DOERUN, C. 1912.

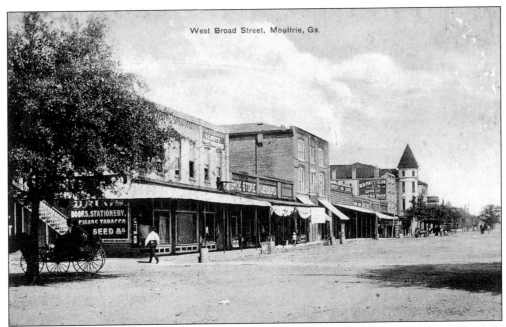

A c. **1908 View of West Broad Street in Moultrie.** Several early businesses in Moultrie can be identified in this view.

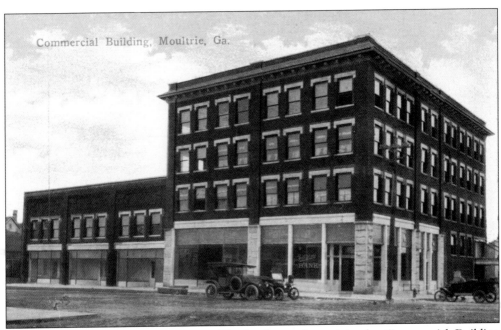

The Citizen's Bank of Moultrie. The bank was located in the Commercial Building shown here in this c. 1912 view. W.H. Barber was president of the bank and A.D. Autry was vice-president.

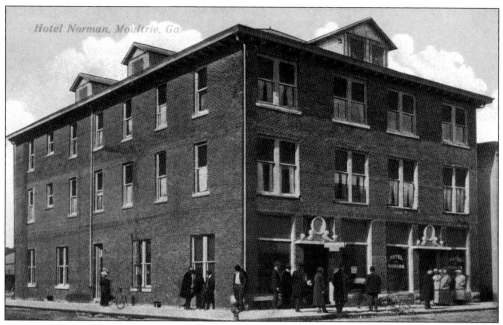

THE HOTEL NORMAN IN MOULTRIE, C. 1912.

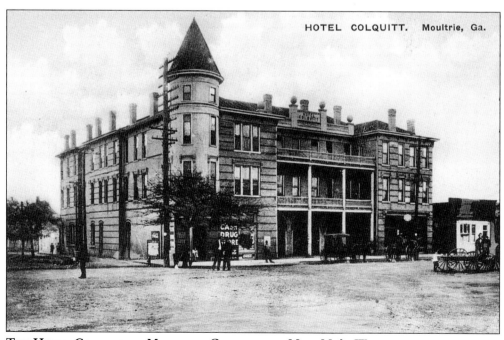

THE HOTEL COLQUITT IN MOULTRIE, OPERATED BY MRS. M.A. WHITAKER.

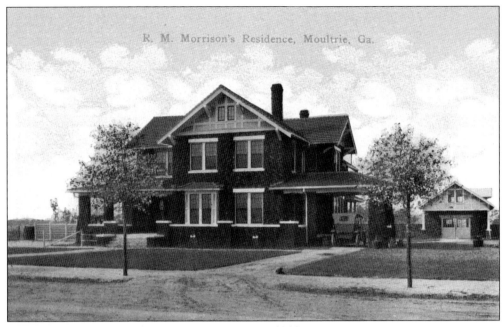

THE HOME OF R.M. MORRISON IN MOULTRIE, *C.* 1912.

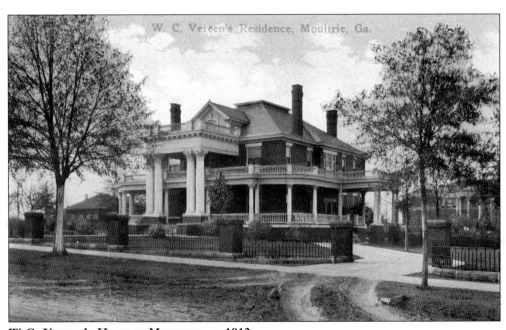

W.C. VEREEN'S HOME IN MOULTRIE, *C.* 1912.

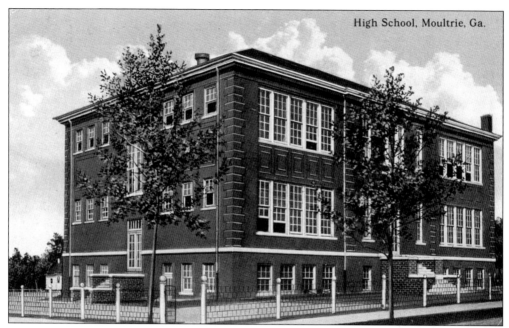

High School, Moultrie, Ga.

THE HIGH SCHOOL IN MOULTRIE. This card was printed about 1912 but was not used until 1918, during World War I. The message reads in part: "In Palatka, Fla. Tuesday. Only 5 men out of about 40 teachers there! 5 years from now, if this war continues, *all* the men will be in war and half the girls. Here they teach spelling and civics in 1st and 3rd yrs. of high school, so I found out yesterday. How would you like that? E.H.C."

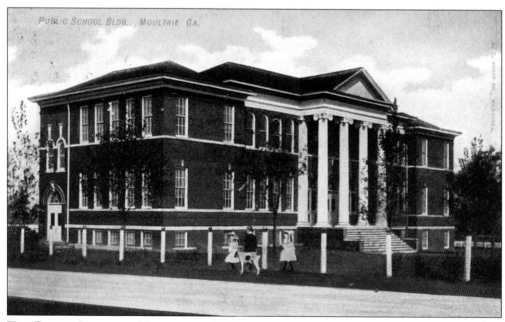

PUBLIC SCHOOL BLDG., MOULTRIE GA.

THE PUBLIC SCHOOL IN MOULTRIE IN 1908.

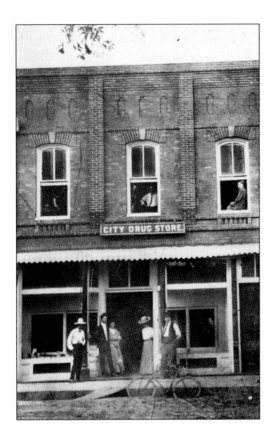

THE CITY DRUG STORE IN BOSTON IN 1907. The store was owned by James C. Adams and Sons.

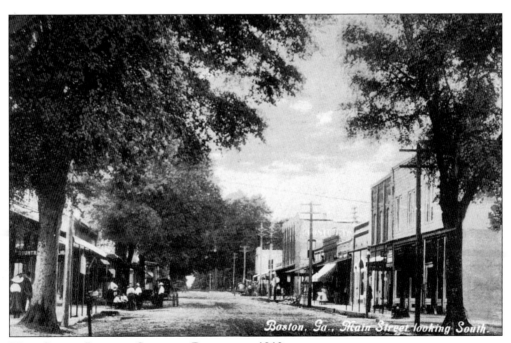

MAIN STREET LOOKING SOUTH IN BOSTON, C. **1912.**

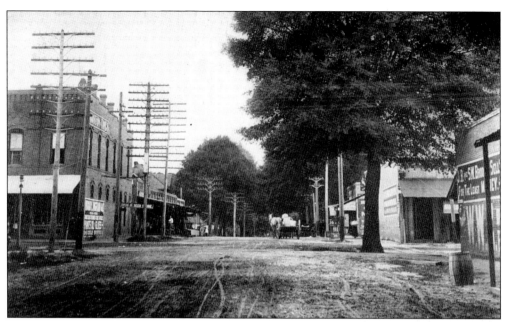

JEFFERSON STREET LOOKING WEST IN BOSTON, C. 1907.

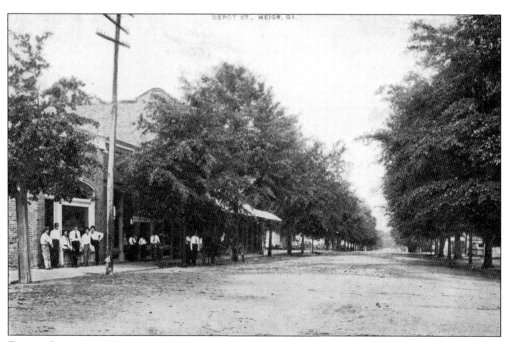

DEPOT STREET IN MEIGS, C. 1910.

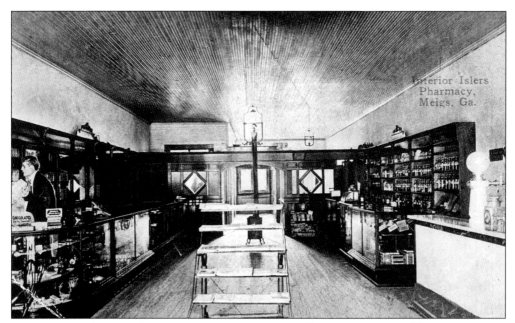

THE INTERIOR OF ISLER'S PHARMACY IN MEIGS. The pharmacy was owned by Dr. James N. Isler.

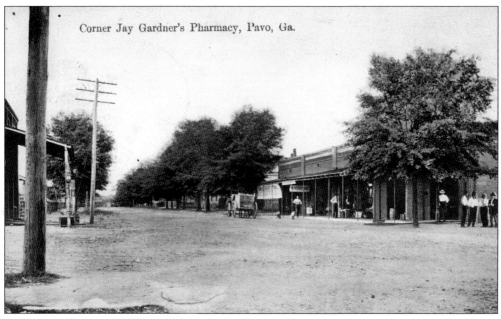

A VIEW OF PAVO IN 1910. Jay D. Gardner's Pharmacy is on the corner.

Two

THOMASVILLE

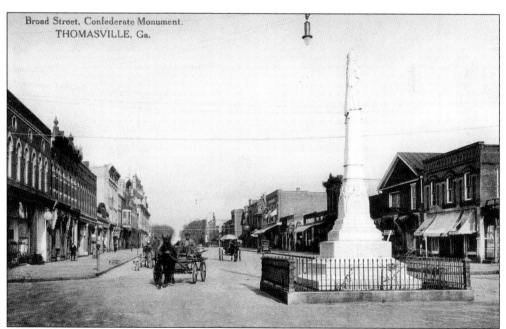

BROAD STREET IN THOMASVILLE ABOUT 1912. Shown here is the Confederate Monument that was unveiled on June 10, 1879, at the intersection with Fletcher Street (now Remington Street). The monument was moved to the Washington Street side of the courthouse lawn in 1946.

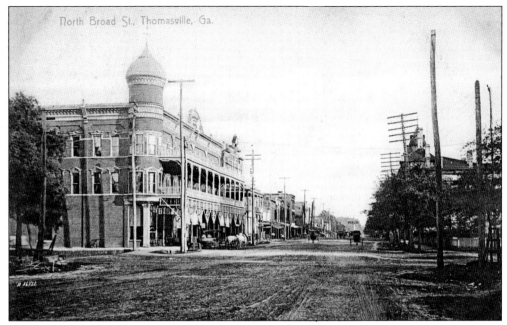

NORTH BROAD STREET IN THOMASVILLE, C. **1906.** The Tosco Hotel is on the corner.

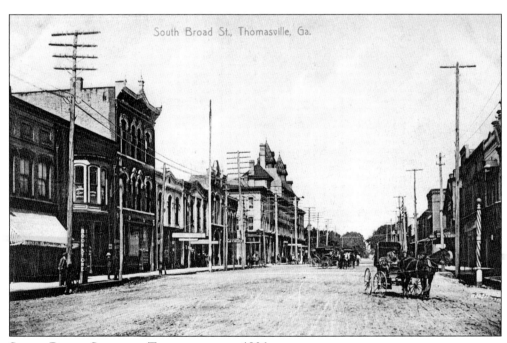

SOUTH BROAD STREET IN THOMASVILLE, C. **1906.**

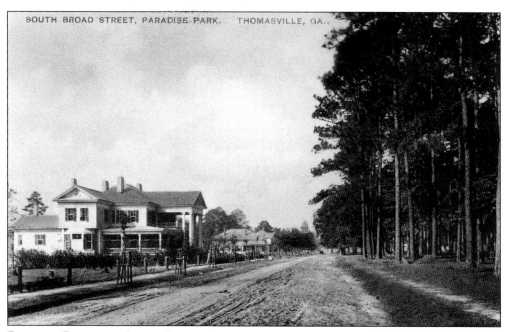

PARADISE PARK, OUT SOUTH BROAD STREET IN THOMASVILLE, *C.* **1912.**

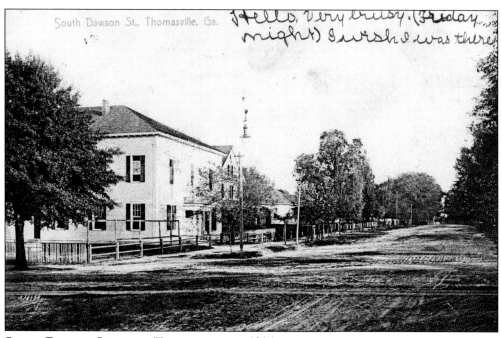

SOUTH DAWSON STREET IN THOMASVILLE, *C.* **1906.**

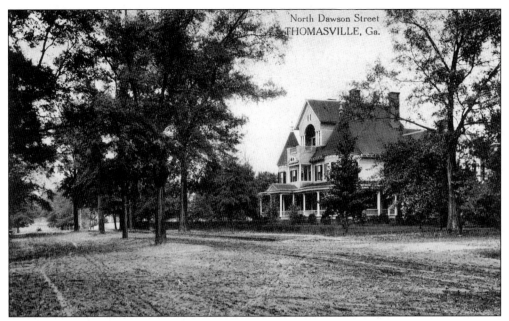

North Dawson Street
THOMASVILLE, Ga.

NORTH DAWSON STREET IN THOMASVILLE, C. **1912.**

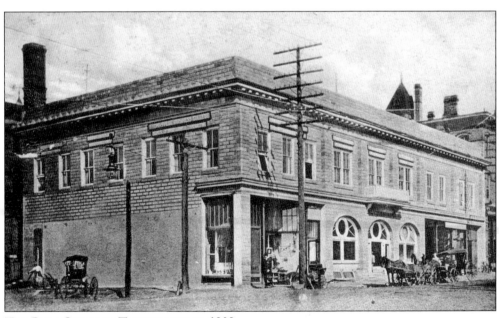

THE POST OFFICE IN THOMASVILLE IN **1908.**

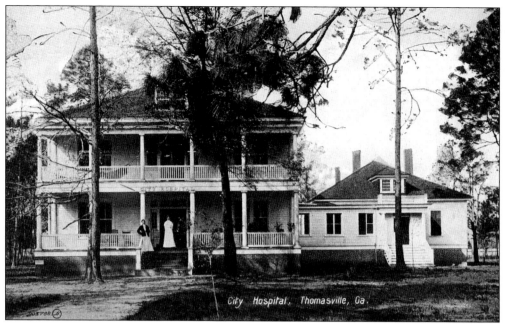

CITY HOSPITAL IN THOMASVILLE, C. 1910.

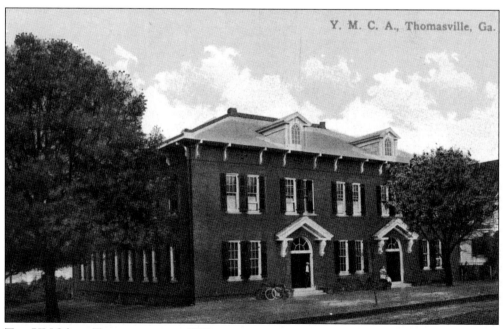

THE YMCA IN THOMASVILLE, C. 1908.

27

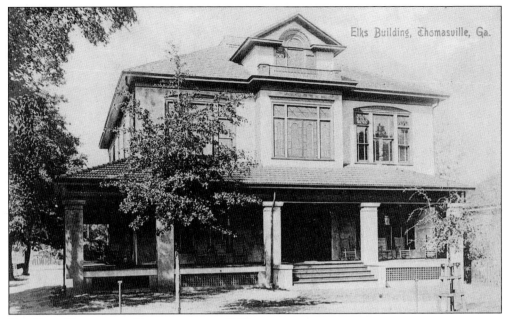

THE ELKS BUILDING IN THOMASVILLE IN 1907.

THE STUART HOUSE IN THOMASVILLE. The hotel was owned by A.N. McBride.

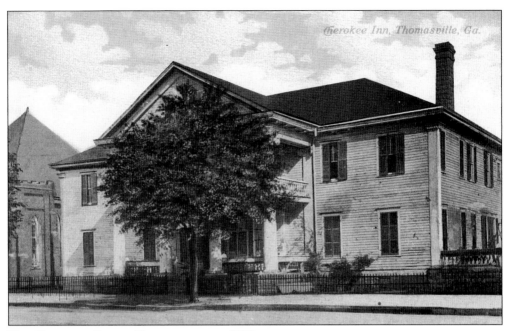

THE CHEROKEE INN IN THOMASVILLE, C. **1910.**

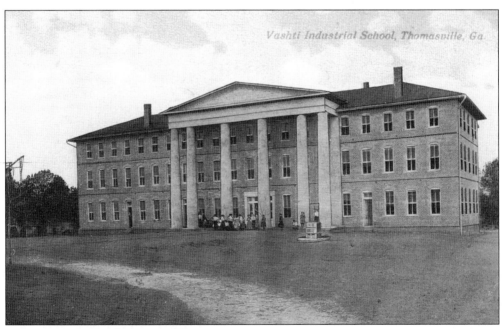

VASHTI INDUSTRIAL SCHOOL IN THOMASVILLE.

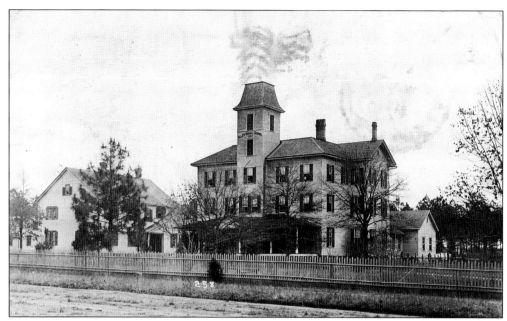

A Real-Photo View Card of Allen Normal School, a Vocational School for Blacks Established in Thomasville in 1888.

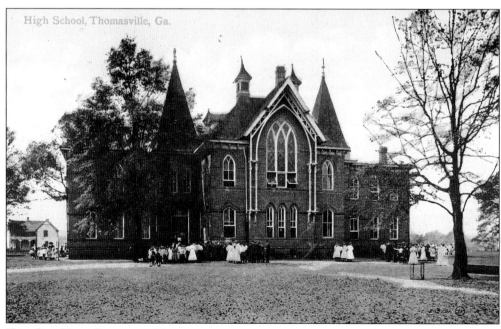

The Old High School in Thomasville.

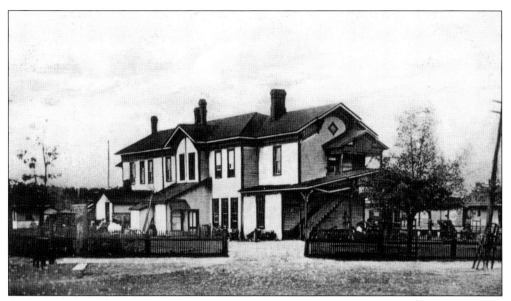

THE RAILROAD DEPOT IN THOMASVILLE IN 1907.

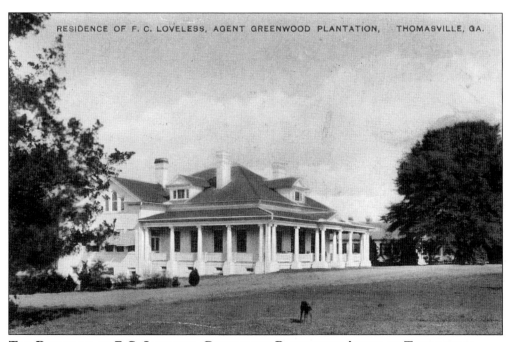

RESIDENCE OF F. C. LOVELESS, AGENT GREENWOOD PLANTATION, THOMASVILLE, GA.

THE RESIDENCE OF F.C. LOVELESS, GREENWOOD PLANTATION AGENT AT THOMASVILLE.

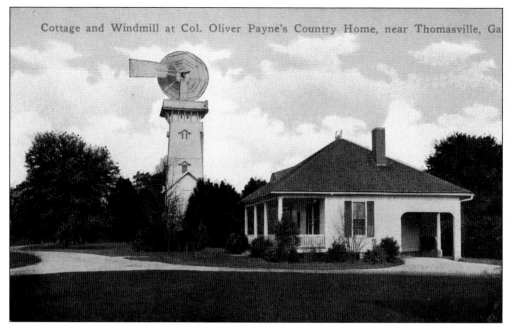

Cottage and Windmill at Col. Oliver Payne's Country Home, near Thomasville, Ga

COTTAGE AND WINDMILL AT COLONEL OLIVER PAYNE'S COUNTRY HOME
NEAR THOMASVILLE.

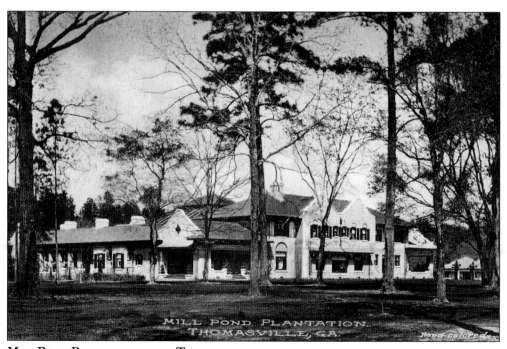

MILL POND PLANTATION.
THOMASVILLE, GA.

MILL POND PLANTATION, NEAR THOMASVILLE.

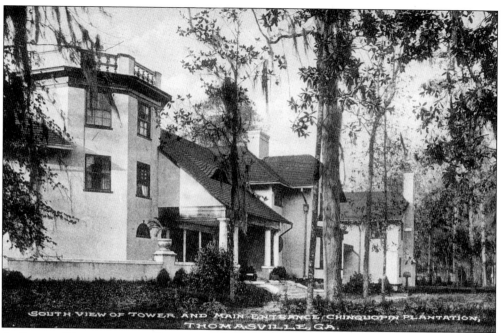

A South View of the Tower and Main Entrance of Chinquapin Plantation near Thomasville.

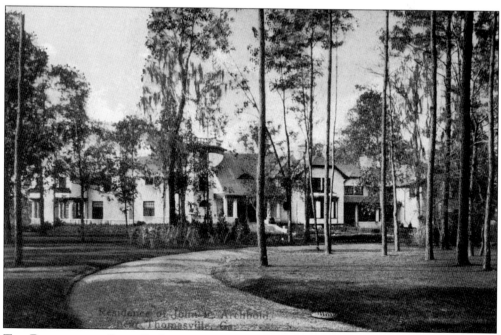

The Residence of John F. Archbold, near Thomasville.

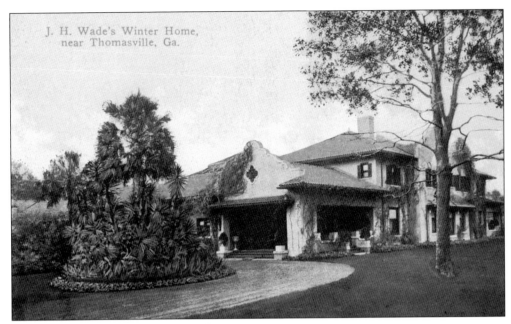

J.H. WADE'S WINTER HOME NEAR THOMASVILLE.

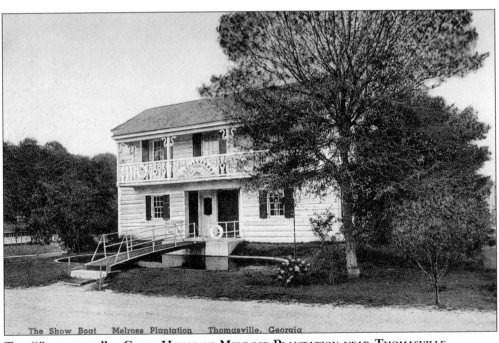

THE "SHOWBOAT," A GUEST HOUSE AT MELROSE PLANTATION NEAR THOMASVILLE.

THE HEBARD RESIDENCE IN THOMASVILLE.

THE HASKELL HOME IN THOMASVILLE.

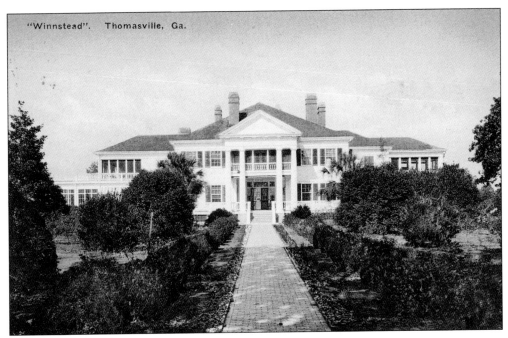

"Winnstead". Thomasville, Ga.

WINNSTEAD, NEAR THOMASVILLE.

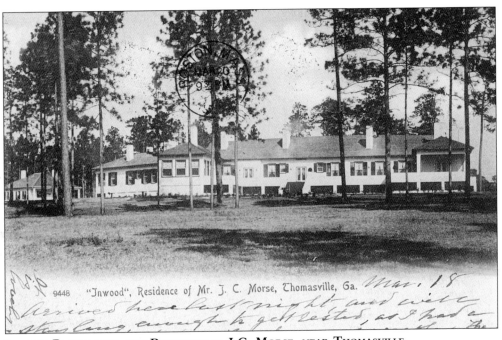

9448 "Inwood", Residence of Mr. J. C. Morse, Thomasville, Ga.

INWOOD PLANTATION, THE RESIDENCE OF J.C. MORSE, NEAR THOMASVILLE.

Two

CALHOUN, DOUGHERTY, EARLY, AND MITCHELL COUNTIES

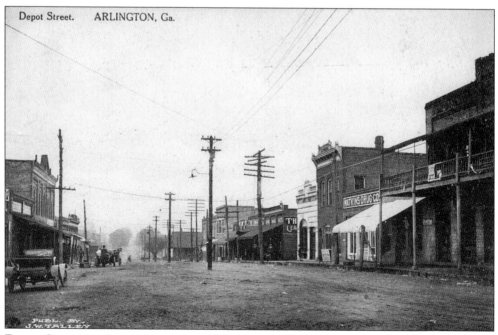

DEPOT STREET IN ARLINGTON IN THE 1910s.

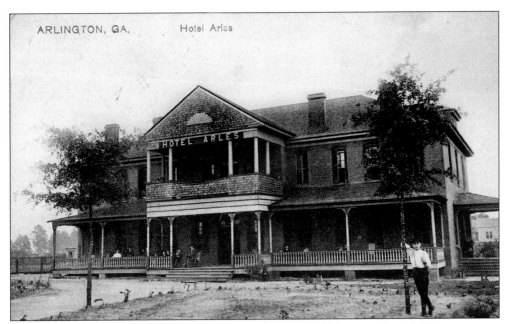

ARLINGTON, GA. Hotel Arles

HOTEL AIRES IN ARLINGTON, *C.* **1908.** The writer sent the following telegraph-like message to Eva in Orono, Maine: "Just arrived in Arlington. This is the place I am hanging my hat tonight. Feeling fine. Nice town. Write often. With Love, Roy."

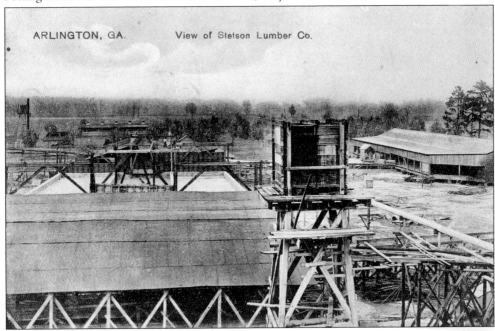

ARLINGTON, GA. View of Stetson Lumber Co.

A VIEW OF PART OF THE STETSON LUMBER COMPANY OPERATIONS AT ARLINGTON, *c.* **1909.** The card was mailed to Dorothy in Sylvania, Georgia, with the following message: "Before breakfast 8/16/09. Received your nice long letter last night. You can write a mighty good one and I will write one to you. You failed to let me know when it is that mama wants to go to Savannah. Glad A.M. is finally rid of his tooth troubles. The scene on the other side is just a small portion of the Stetson plant and does not show any of the mills. Papa."

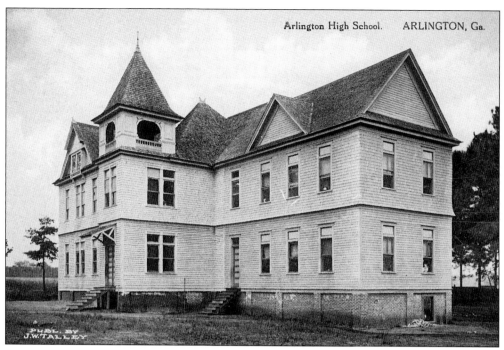

Arlington High School, an Attractive Large Wooden Building.

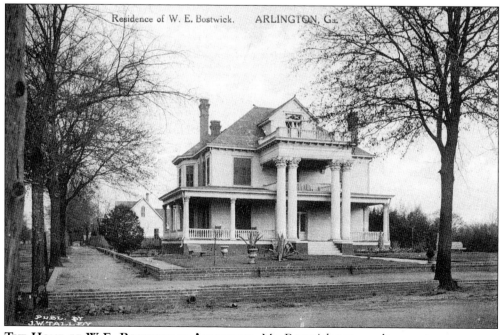

The Home of W.E. Bostwick in Arlington. Mr. Bostwick was a realtor.

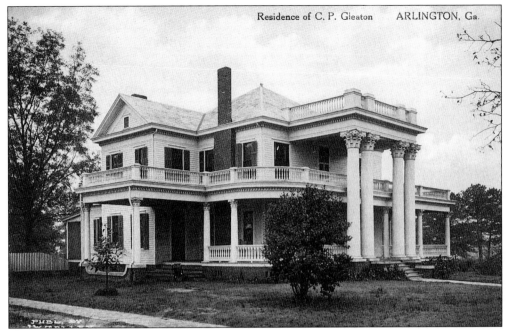

THE RESIDENCE OF **C.P. GLEASON** IN **ARLINGTON**.

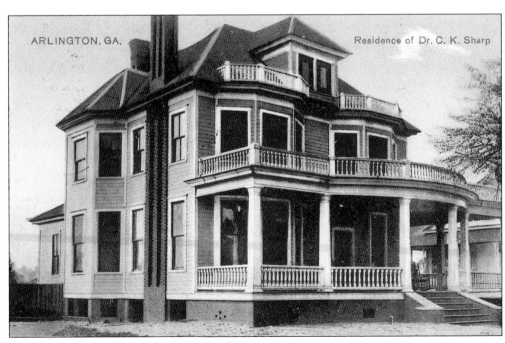

THE RESIDENCE OF **DR. C.K. SHARP** IN **ARLINGTON**.

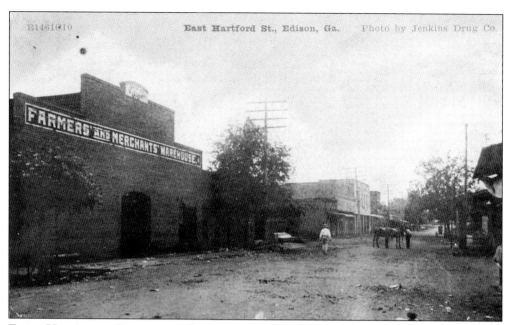

EAST HARTFORD STREET IN EIDSON IN 1908. This view shows the Farmers' and Merchants' Warehouse.

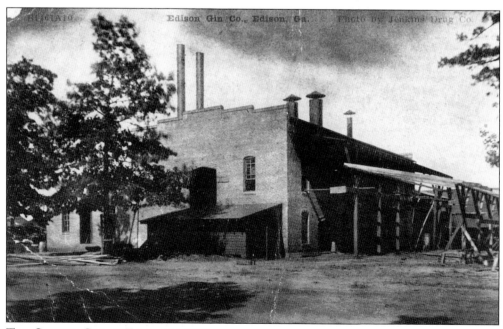

THE COTTON GIN AT EIDSON IN 1908.

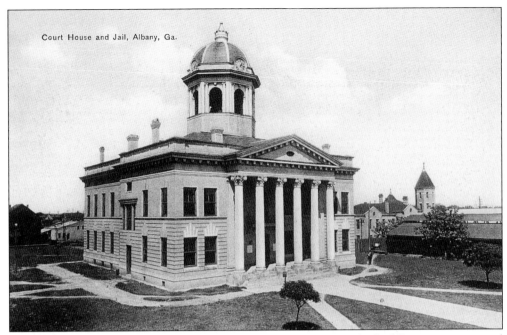

Court House and Jail, Albany, Ga.

THE DOUGHERTY COUNTY COURTHOUSE BUILDING IN ALBANY. The building was constructed in 1904 and burned in 1966.

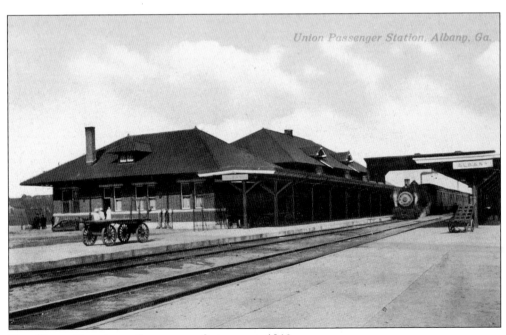

Union Passenger Station, Albany, Ga.

THE UNION PASSENGER STATION IN ALBANY, C. **1910.**

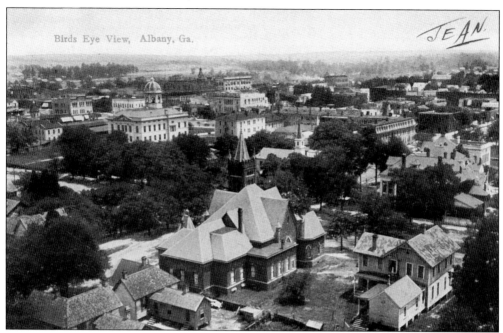

A Bird's-eye View of Albany, c. 1908, Showing a Large Part of the Town.

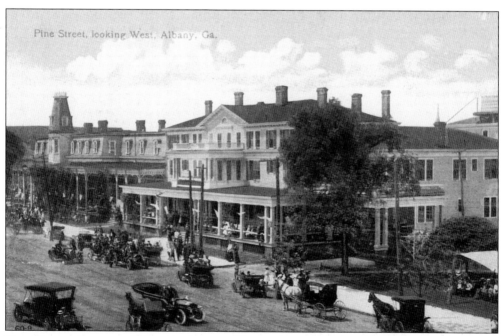

PINE STREET LOOKING WEST IN ALBANY. The card was mailed to Smithsburg, Maryland, on July 2, 1913, with the message: "Better practice up a bit on your bowling. Havent seen an alley since been away but when I get back, probably next week, will make you dig up for a few games. I should worry. L.C.M."

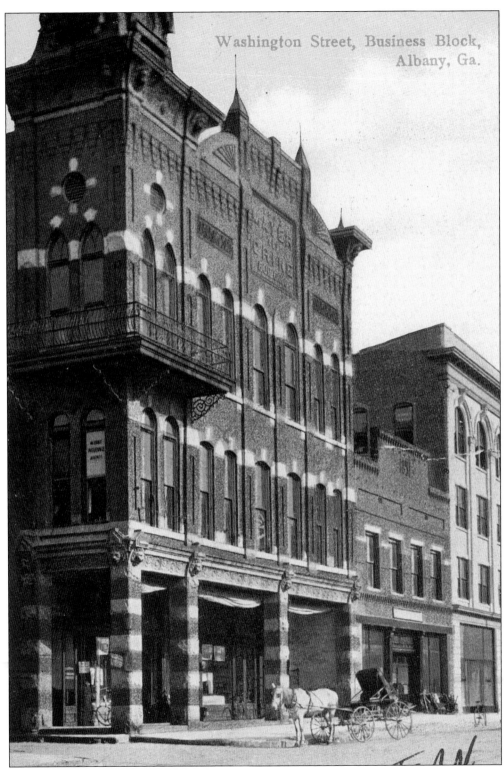

Washington Street, Business Block,
Albany, Ga.

A BUSINESS BLOCK IN ALBANY, *C.* 1910.

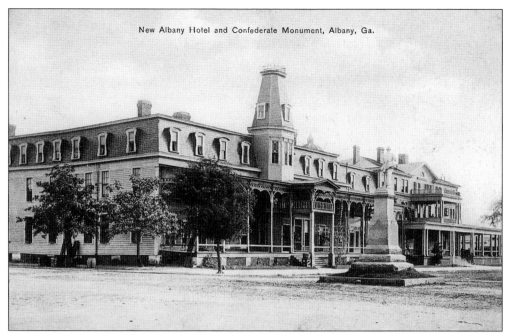

New Albany Hotel and Confederate Monument, Albany, Ga.

THE NEW ALBANY HOTEL AND CONFEDERATE MONUMENT IN ALBANY AT THE INTERSECTION OF JACKSON AND PINE STREETS. The hotel was managed by Mr. E.B. Young and rates were $2 and $3 per day. The monument was dedicated November 13, 1901. The monument was hit by an automobile in the 1930s and was moved out of the street to a small park. It was later moved to its present location in Riverside Cemetery.

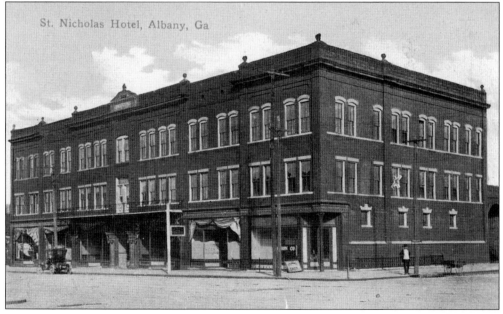

St. Nicholas Hotel, Albany, Ga

A FULL VIEW OF THE ST. NICHOLAS HOTEL IN ALBANY. The written message reads in part: "My Georgia Darling the X on the window was our room for one day. we are in a well looking house now, just have a room and bath, and take our meals out. they have two nickel shows here, only they charge 10 cents for it. Mama."

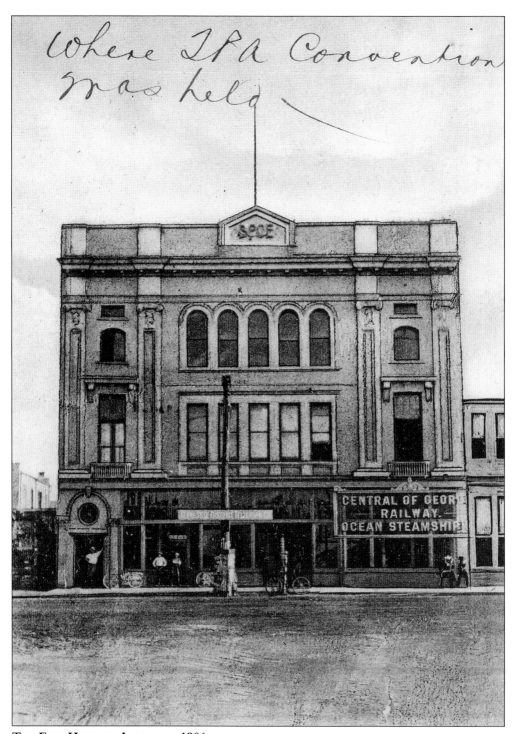

Where IPA Convention was held

THE ELKS HOME IN ALBANY IN 1906.

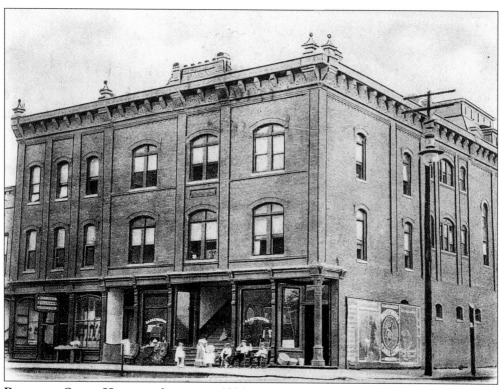

Rawlings Opera House in Albany in 1906.

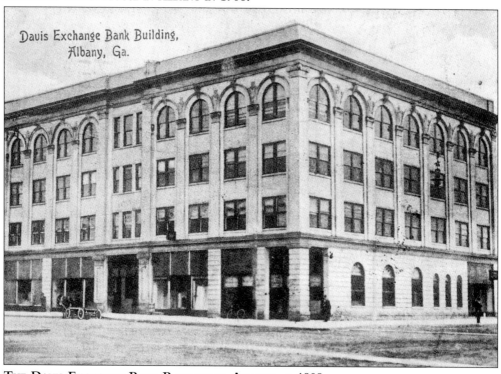

Davis Exchange Bank Building, Albany, Ga.

The Davis Exchange Bank Building in Albany, c. 1908.

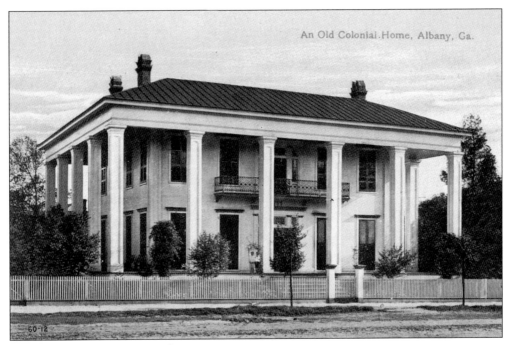

An Old Colonial Home, Albany, Ga.

AN OLD COLONIAL HOME IN ALBANY.

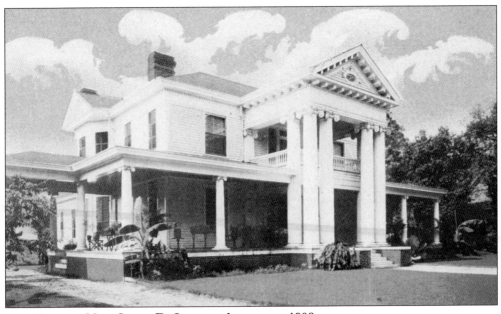

THE HOME OF MRS. SALLIE D. JONES IN ALBANY, C. 1908.

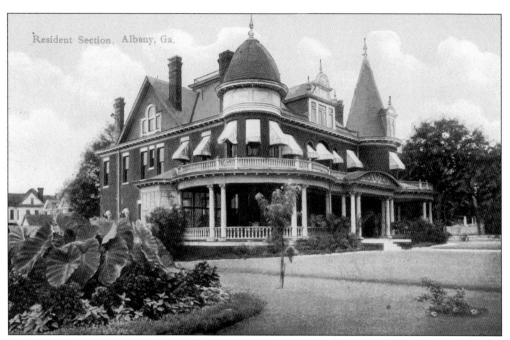

A Private Home, Albany, *c.* **1908.** Surely this house in Albany must have been one of the fanciest residences in town.

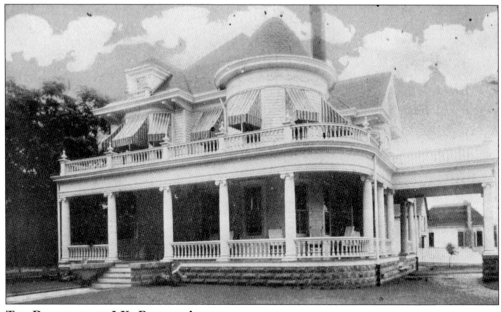

The Residence of J.K. Pray in Albany.

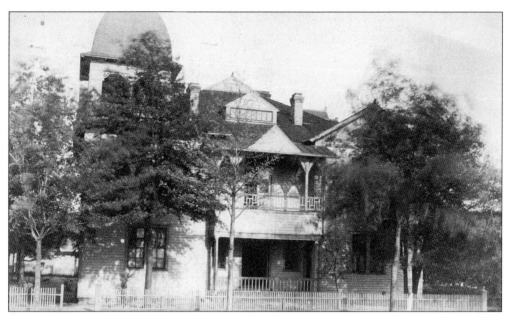

A REAL-PHOTO VIEW OF A SCHOOL IN ALBANY IN 1909. The card was mailed to Norwich, Connecticut, with the following message: "This is our school. Our house is further down the street. Will send you a picture of it later. Yours, L."

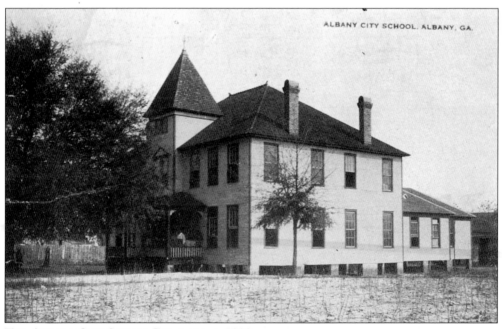

ALBANY CITY SCHOOL, ALBANY, GA.

THE ALBANY CITY SCHOOL BUILDING, *C.* **1908.**

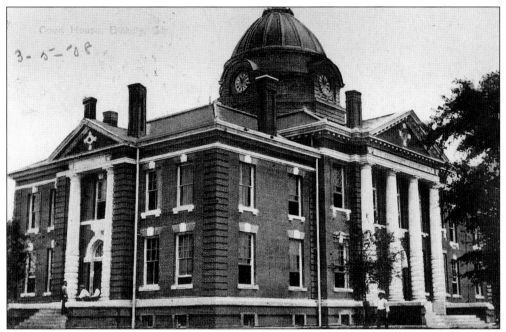

THE EARLY COUNTY COURTHOUSE AT BLAKELY. The courthouse was completed in 1906 at a cost of $50,000 and is still in use. The county is named for Peter Early, governor of Georgia from 1813 to 1815, and the town is named for Captain Johnston Blakely, commander of the USS *Wasp* during the War of 1812.

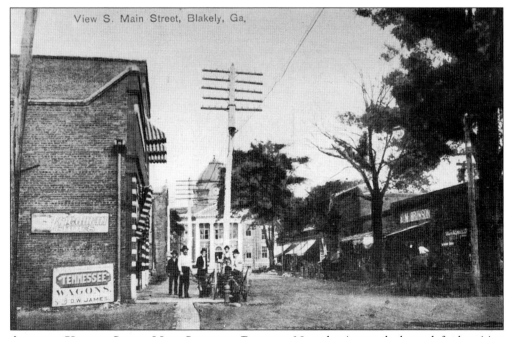

AN EARLY VIEW OF SOUTH MAIN STREET IN BLAKELY. Note the sign on the lower left advertising Tennessee wagons.

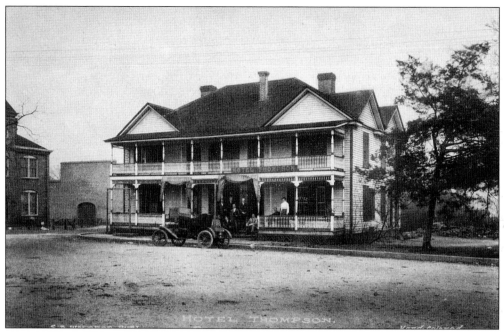

THE HOTEL THOMPSON IN BLAKELY. The hotel was run by Mrs. A.Y. Thompson. This card was mailed to South Meriden, Connecticut, on April 11, 1912, with this message: "Hello! Miss Nellie. How are you today? Your cards received. Am always glad to hear from you. Have been looking for a letter a long time. Would have answered your cards B 4 now, but have been so busy. Ans. soon. Your friend, C.G."

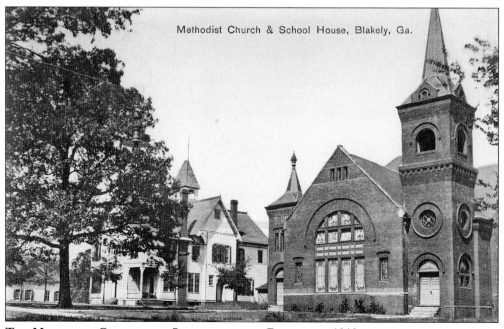

THE METHODIST CHURCH AND SCHOOLHOUSE IN BLAKELY IN 1910.

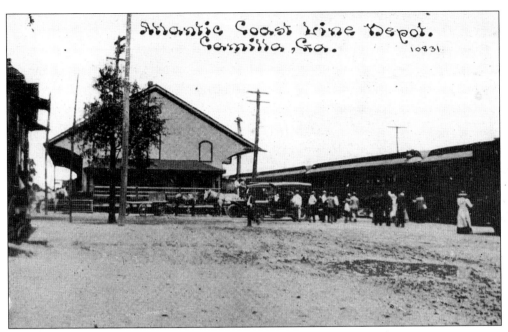

THE ATLANTIC COAST LINE RAILROAD DEPOT IN CAMILLA ABOUT 1910.

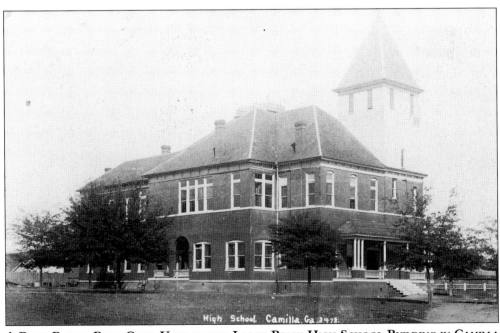

A REAL-PHOTO POST CARD VIEW OF THE LARGE BRICK HIGH SCHOOL BUILDING IN CAMILLA ABOUT 1909.

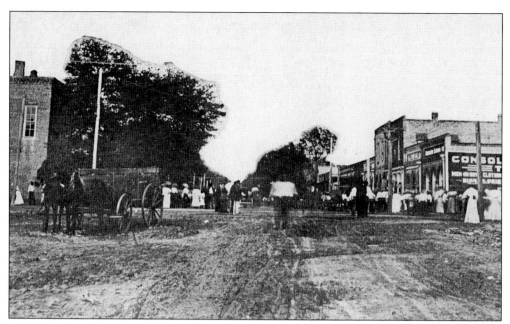

BROAD STREET LOOKING EAST IN CAMILLA.

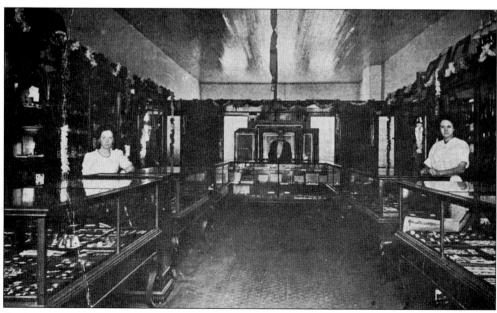

AN INTERIOR VIEW OF THE CITY JEWELRY STORE IN CAMILLA.

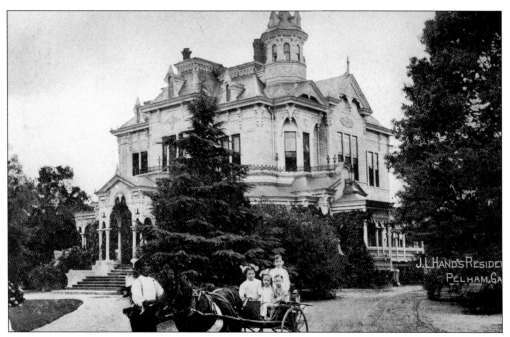

THE PALATIAL HOME OF J.L. HAND AT PELHAM. Shown are four children in a two-wheel pony cart out front. The card was postmarked December 7, 1908, and the written message identifies the children as members of the Hand family.

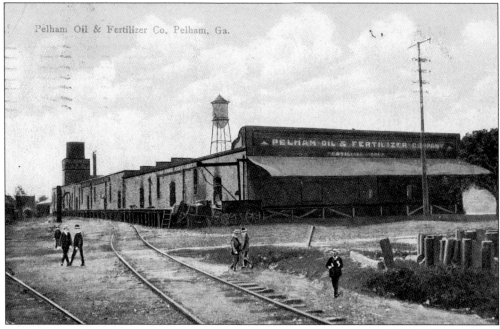

THE PELHAM OIL & FERTILIZER COMPANY IN PELHAM. J.L. Hand was president and manager of the company.

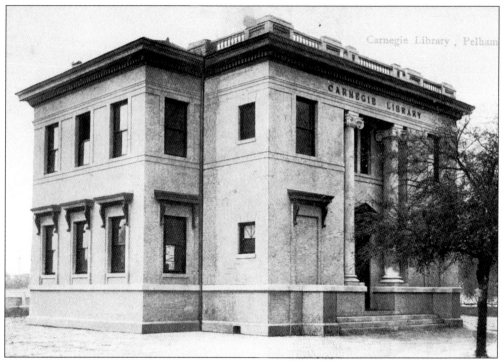

THE CARNEGIE LIBRARY IN PELHAM.

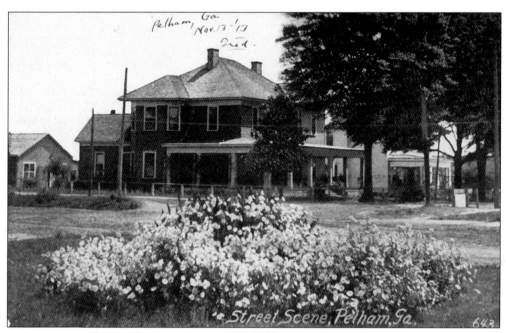

A RESIDENTIAL STREET SCENE IN PELHAM, C. 1912.

Three

CLAY, RANDOLPH, STEWART, AND TERRELL COUNTIES

MAIN STREET, BLUFFTON. This post card was mailed to Marshallville, Georgia, on May 12, 1910, with this message: "You had better come home. We are having numerous Gala Days during Commencement Week. I really mean it too. You and H. can't believe B town is gay but come & we will show you."

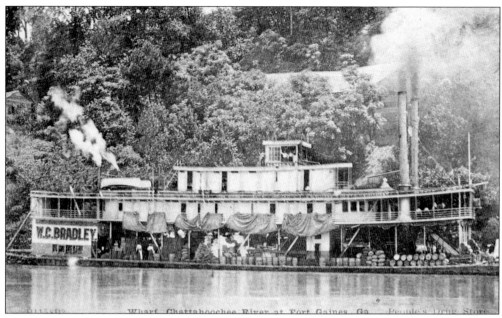

THE STERN-WHEELER *W.C. BRADLEY* **AT THE WHARF AT FORT GAINES ON THE CHATTAHOOCHEE RIVER, ABOUT 1910.** This boat had a regular run from Columbus, Georgia, to Apalachee, Florida, hauling passengers and freight.

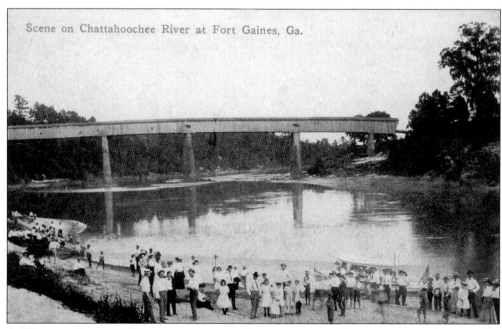

Scene on Chattahoochee River at Fort Gaines, Ga.

A WOODEN COVERED BRIDGE ACROSS THE CHATTAHOOCHEE RIVER AT FORT GAINES. This must have been one of the longest in the state. A written statement on the card said that it was 900 feet long.

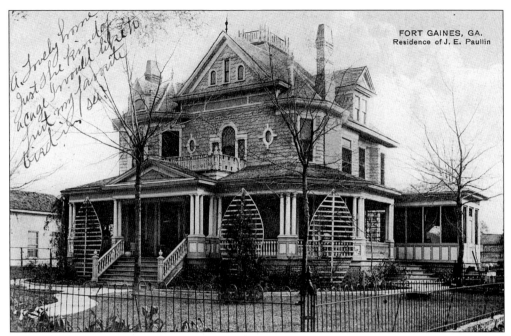

The Residence of J.E. Paulin in Fort Gaines. The card was mailed anonymously to Miss L.S. in Jacksonville, Florida, on March 21, 1909. The message written on the top left of this side states: "A lovely home. Just the kind of a cage I would like to put my favorite bird in, see?"

The Public School at Fort Gaines. Quite a crowd of students are posed out front.

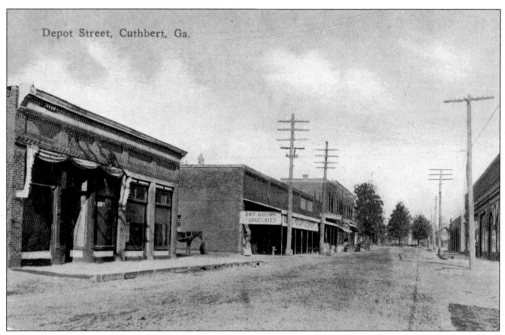

DEPOT STREET IN CUTHBERT, C. **1910.**

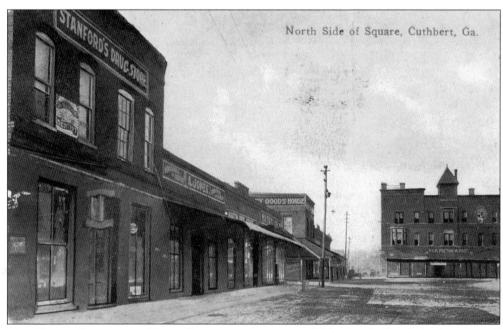

THE NORTH SIDE OF THE TOWN SQUARE IN CUTHBERT. W.B. Stanford's wholesale and retail drug store is on the left. Next is A. Jones' Grocery, which also dealt in crockery, glassware, and other items. The next store was Martin's Shoe Store, then W.O. Taylor & Company, dealer in dry goods, hats, and shoes.

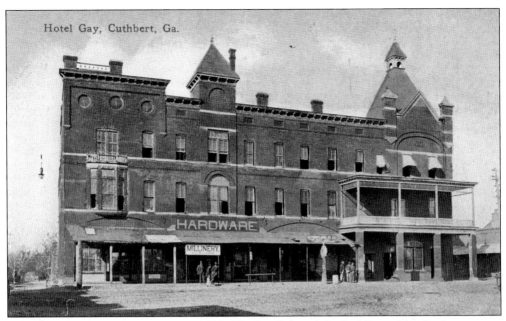

THE HOTEL GAY IN CUTHBERT, C. 1908. The hotel shared the building with a hardware store, a millinery shop, and a jewelry store.

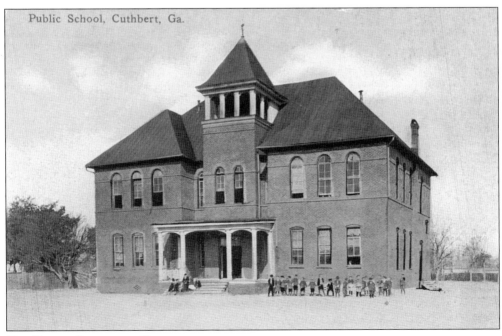

THE PUBLIC SCHOOL AT CUTHBERT.

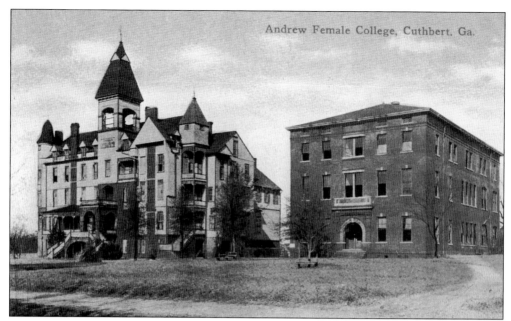

Andrew Female College, Cuthbert, Ga.

The Andrew Female College at Cuthbert. The college was founded in 1854.

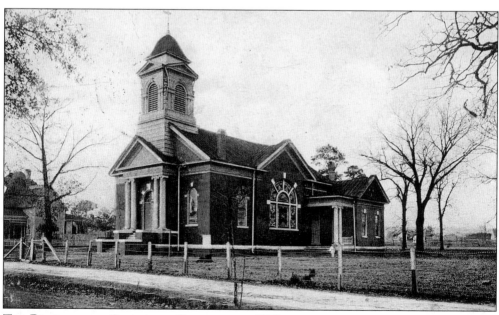

The Presbyterian Church at Cuthbert, c. **1907.**

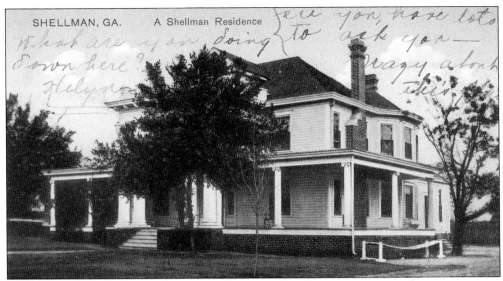

SHELLMAN, GA. A Shellman Residence

A PRIVATE RESIDENCE IN SHELLMAN. The card was mailed to Cuthbert, 12 miles away on September 30, 1909, with the following message: "Hello Mr. Porter. Will be at home Sunday, but sorry I have a date. Will pass through Cuthbert at 8 o'clock Sunday morning & again Sunday night. How are our Atlanta friends? Would like to see you, have lots to ask you. Crazy about this place. what are you doing down here? Helyn."

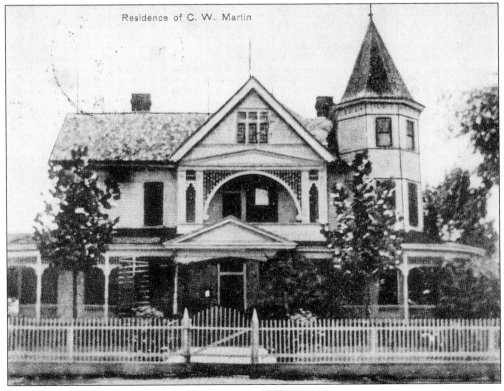

Residence of C. W. Martin

THE HOME OF C.W. MARTIN IN SHELLMAN IN 1907.

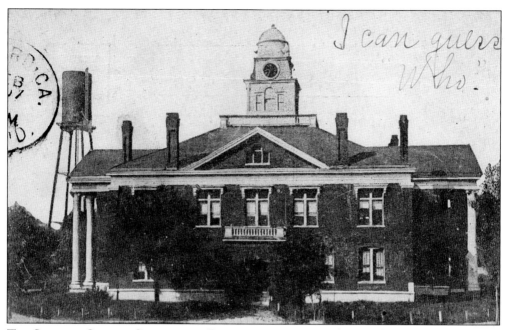

THE STEWART COUNTY COURTHOUSE BUILDING IN LUMPKIN. The courthouse was built in 1895 and burned in 1923.

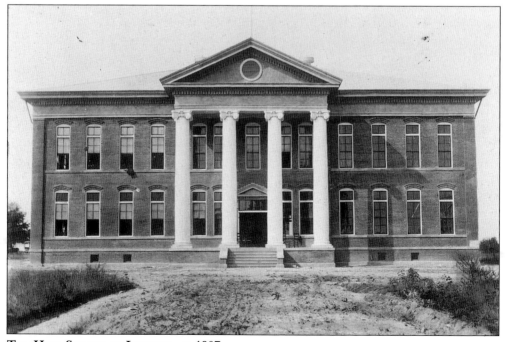

THE HIGH SCHOOL IN LUMPKIN, *C.* **1907.**

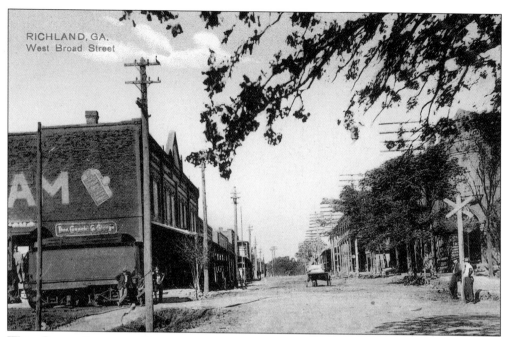

West Broad Street in Richland.

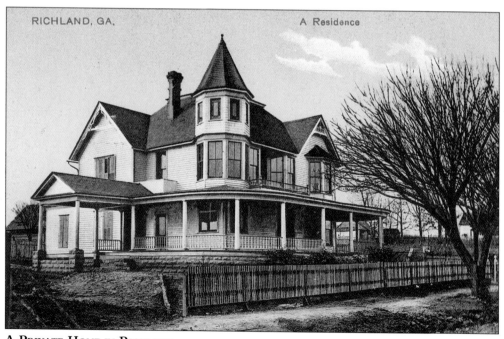

A Private Home in Richland.

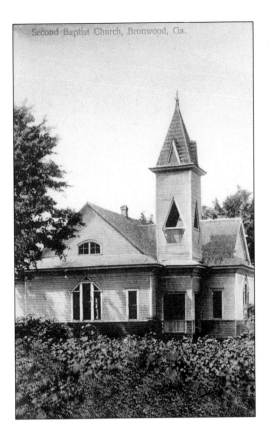

THE SECOND BAPTIST CHURCH IN BRONWOOD. Visible here is its unusual and attractive belfry.

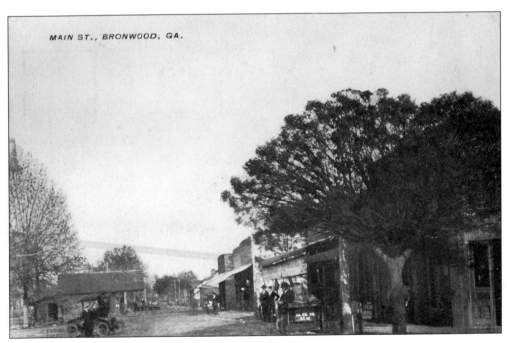

MAIN STREET IN BRONWOOD.

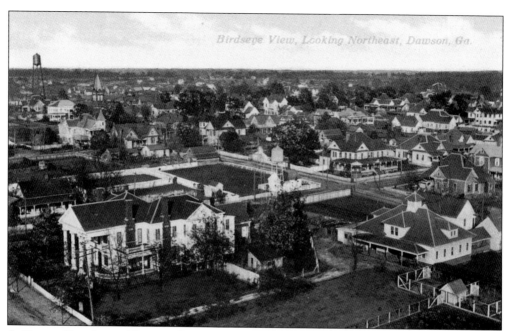

A GRAND BIRD'S-EYE VIEW OF DAWSON, LOOKING NORTHEAST.

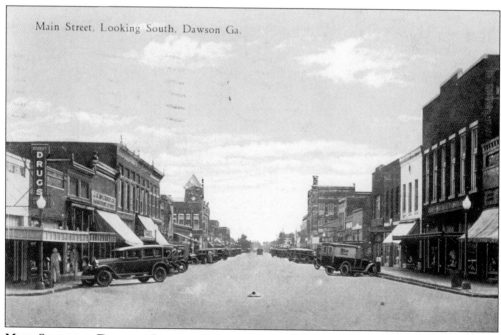

MAIN STREET IN DAWSON, LOOKING SOUTH ABOUT 1930.

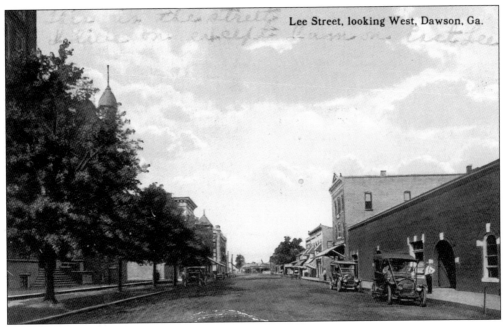

LEE STREET IN DAWSON, LOOKING WEST.

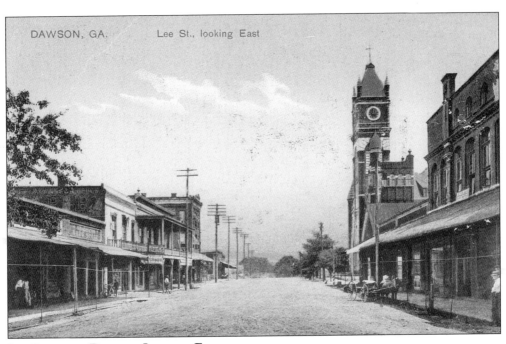

LEE STREET IN DAWSON, LOOKING EAST.

THE CITY NATIONAL BANK IN DAWSON.

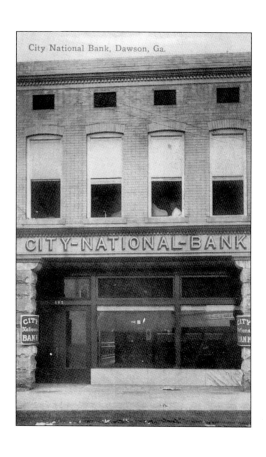

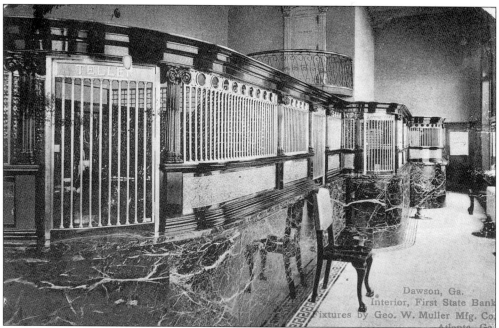

THE INTERIOR OF THE FIRST STATE BANK IN DAWSON.

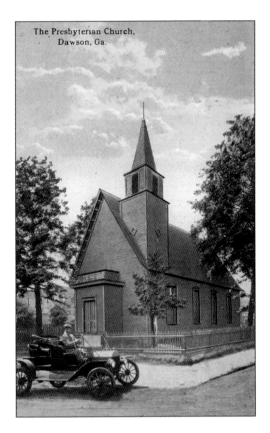

The Presbyterian Church,
Dawson, Ga.

THE PRESBYTERIAN CHURCH IN DAWSON.

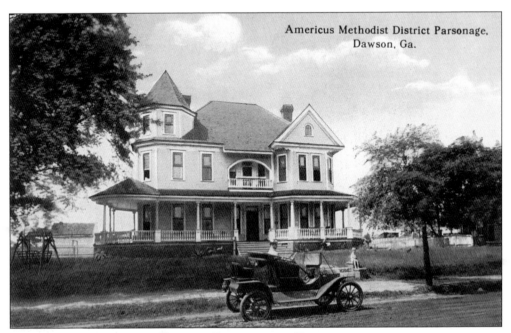

Americus Methodist District Parsonage,
Dawson, Ga.

THE AMERICAN METHODIST DISTRICT PARSONAGE IN DAWSON.

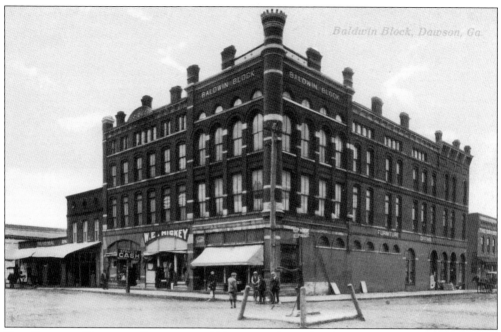

THE BALDWIN BLOCK IN DAWSON, *C.* **1910.** Note the well with a hand pump in the middle of the intersection.

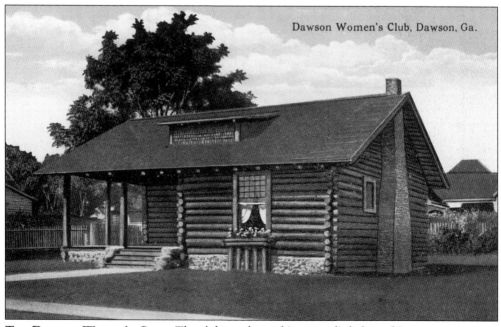

THE DAWSON WOMEN'S CLUB. The club was housed in a neat little log cabin.

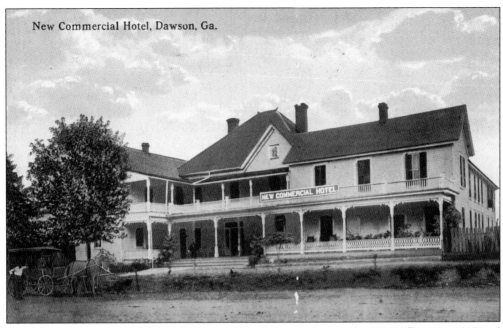

New Commercial Hotel, Dawson, Ga.

THE NEW COMMERCIAL CLUB IN DAWSON. The club was managed by J.P. Williams in 1910 and a room cost $2.00 per day.

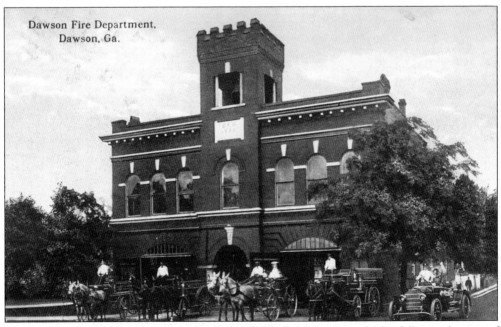

Dawson Fire Department, Dawson, Ga.

THE DAWSON FIRE DEPARTMENT IN ABOUT 1915. The department had a full complement of horse-drawn and motorized fire-fighting equipment.

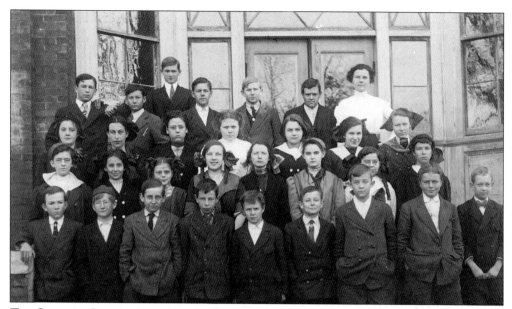

THE SEVENTH GRADE AT THE DAWSON PUBLIC SCHOOL, C. 1910.

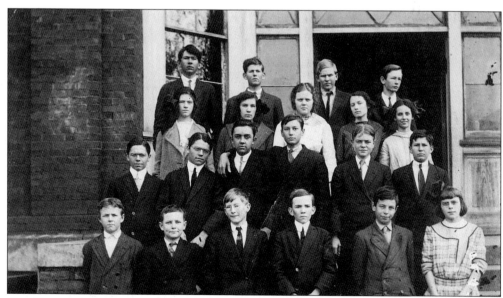

THE EIGHTH GRADE AT THE DAWSON PUBLIC SCHOOL, C. 1910.

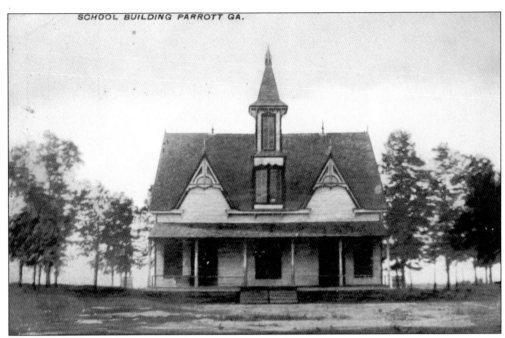

THE SCHOOL BUILDING AT PARROTT, C. 1909.

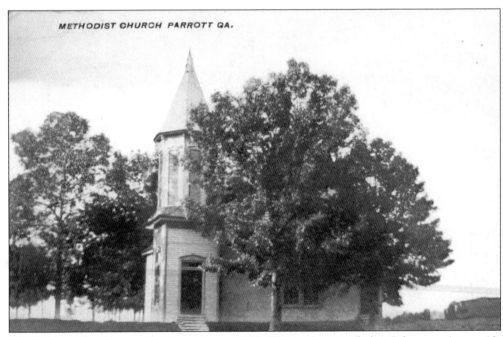

THE METHODIST CHURCH AT PARROTT, C. 1909. The card was mailed to Atlanta on August 13, 1909, with the following short message: "I am coming back to go to school in Sept. I don't like this place at all. Margauite."

Four

CRISP, TIFT, TURNER, AND WORTH COUNTIES

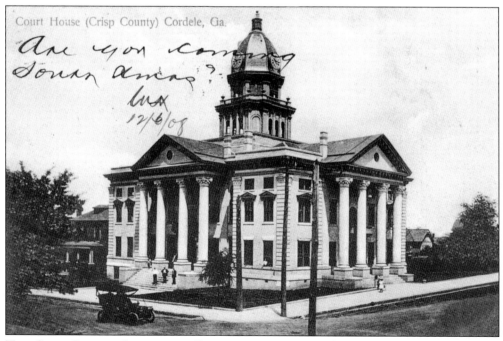

THE CRISP COUNTY COURTHOUSE BUILDING IN CORDELE. The courthouse was built in 1907 and burned in 1950.

A View of Northeastern Cordele. This photograph was taken from the dome of the courthouse about 1908.

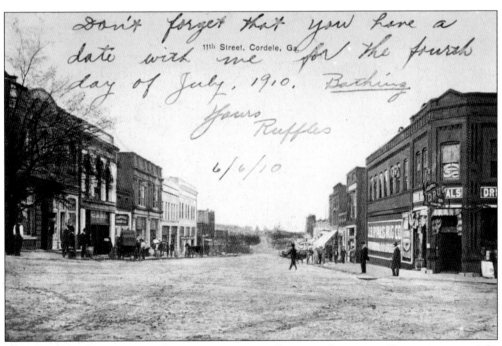

Eleventh Street from the Intersection with Seventh Street in Cordele, with J.B. Ryals Drug Company on the Right. The intriguing message written on the front of the card states: "Don't forget that you have a date with me for the fourth day of July, 1910. *Bathing.* Yours Ruffles 6/6/10."

THE CORDELE NATIONAL BANK. The bank claimed a capital of $50,000 in 1910. The president was B.P. O'Neal, E.P. McBurney was vice-president, B.S. Dunlap was cashier, and C.L. West was assistant cashier.

THE AMERICAN NATIONAL BANK IN CORDELE. In 1910, the bank boasted that their capital had reached $100,000. At that time the president was L.O. Benton, the vice-president was R.L. Wilson, J.W. Cannon was cashier, and E.A. Vinson was assistant cashier.

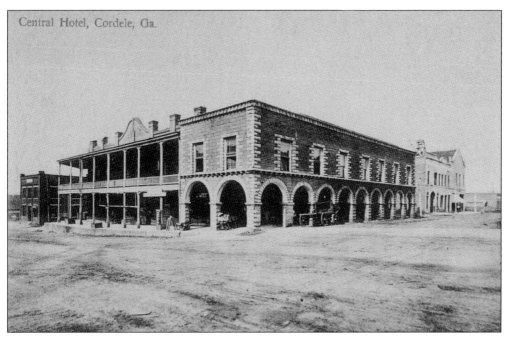

THE CENTRAL HOTEL IN CORDELE. In 1910, J.C. Geiger was proprietor.

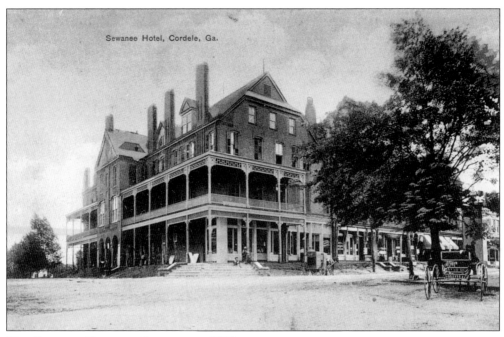

THE SEWANEE HOTEL IN CORDELE, C. 1908.

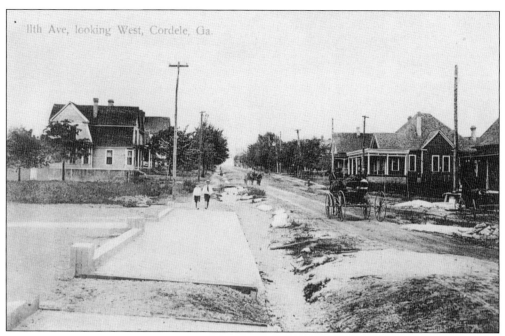

ELEVENTH AVENUE LOOKING WEST IN CORDELE, C. 1909.

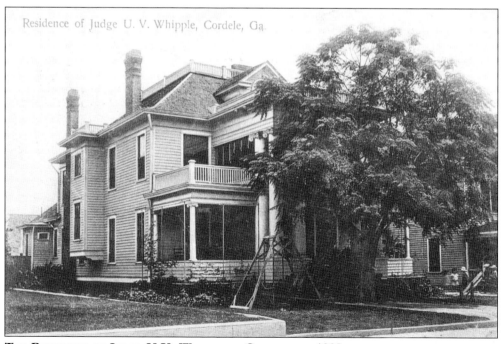

THE RESIDENCE OF JUDGE U.V. WHIPPLE IN CORDELE, C. 1908.

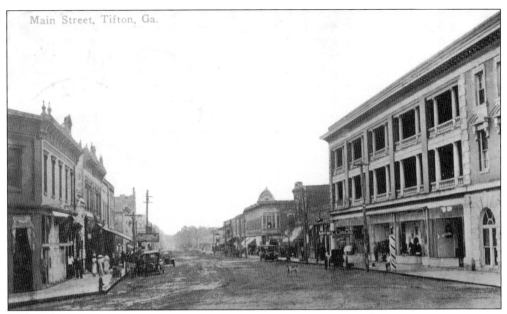

MAIN STREET IN TIFTON, *C.* **1910.** Part of the Hotel Myon can be seen on the right.

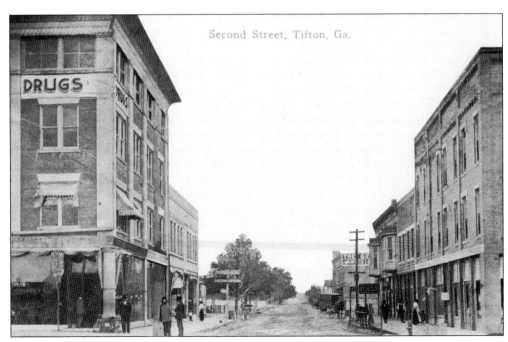

SECOND STREET IN TIFTON, *C.* **1910.**

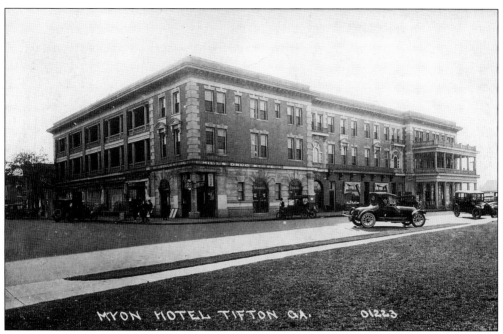

A Full View of the Hotel Myon in Tifton in the early 1920s. This was Tifton's leading hotel.

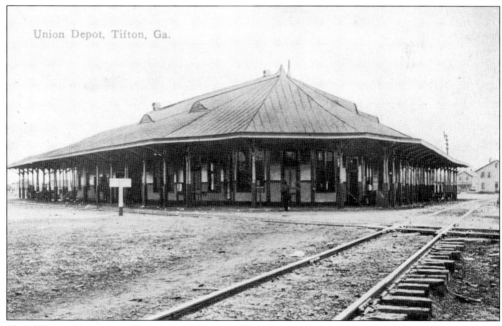

The Union Railroad Depot in Tifton. The town was served by the Atlanta, Birmingham, & Atlantic Railroad; the Atlantic Coast Line Railroad; and the Georgia Southern & Florida Railroad.

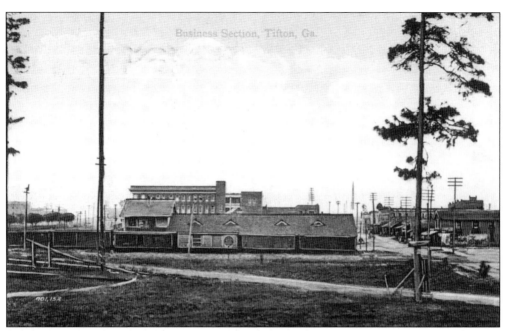

A View of the Business Section of Tifton, c. 1910.

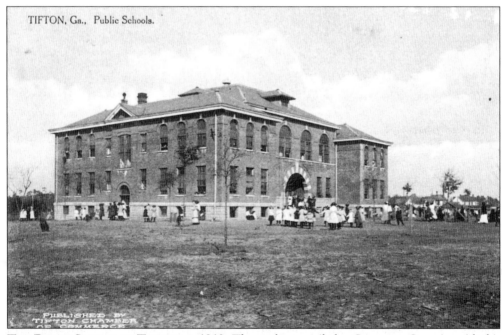

The Public School at Tifton, c. 1912. The card was mailed to Suwanee, Georgia, with this message: "Dear Miss C. Wish you could be with us. We're having a grand time in Tift Co. Guess I will go home Sun. Am stuck on a young preacher, see? Love from Nancy."

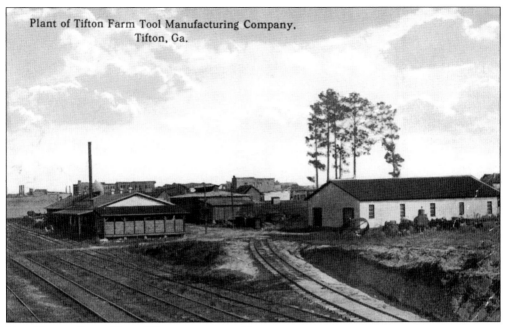

Plant of Tifton Farm Tool Manufacturing Company, Tifton, Ga.

THE TIFTON FARM TOOL MANUFACTURING COMPANY.

DR. F.B. PICKETT'S HOME ON CENTRAL AVENUE IN TYTY.

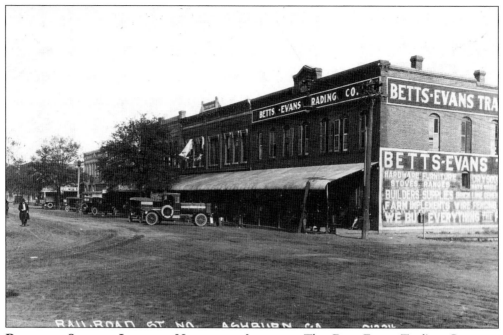

RAILROAD STREET, LOOKING NORTH IN ASHBURN. The Betts-Evans Trading Company occupied the corner building.

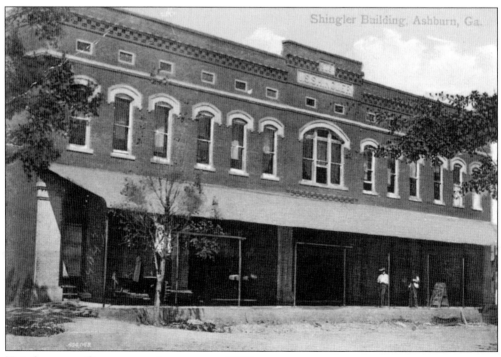

THE SHINGLER BUILDING IN ASHBURN, *C.* 1912.

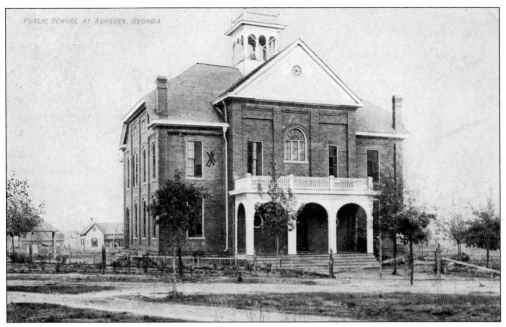

THE PUBLIC SCHOOL BUILDING IN ASHBURN, C. 1910.

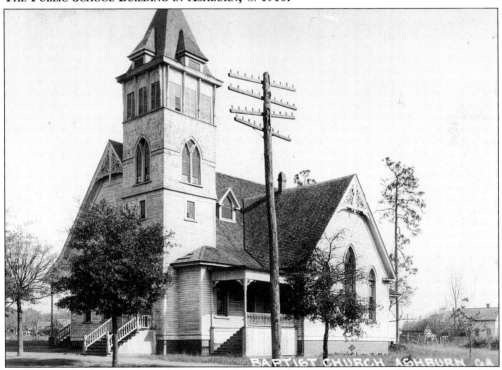

A REAL-PHOTO POST CARD SHOWING THE BAPTIST CHURCH IN ASHBURN. The card was mailed to Beechwood, Kentucky, on December 1, 1921. The message reads: "Dear Marjorie, I have been driving over this section since coming here and I like the country fine. There are many large plantations in Southern Ga. Roses are still in bloom. Have had ripe tomatoes, grown here, nearly every day. Hope you are well. Lovingly Daddy."

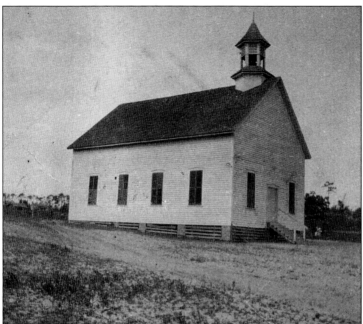

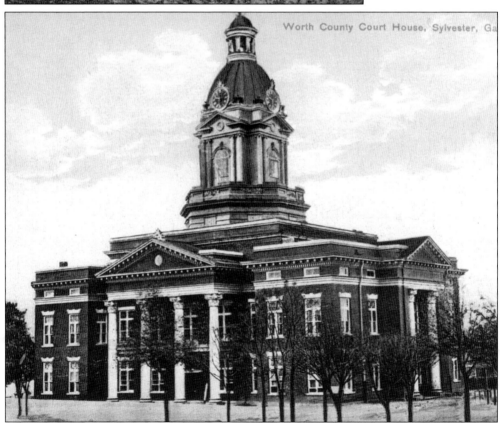

THE WORTH COUNTY COURTHOUSE BUILDING IN SYLVESTER. The courthouse was built in 1905 and burned in 1982.

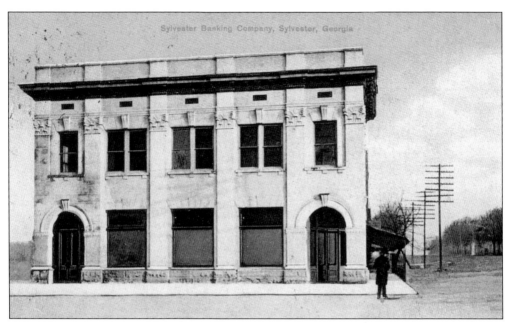

THE SYLVESTER BANKING COMPANY ABOUT 1910. G.G. Ford was president at this time.

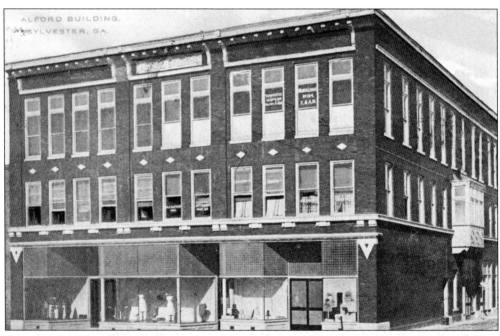

THE ALFORD BUILDING IN SYLVESTER. The card was mailed to Macon on August 6, 1914, with this message: "Wonder what you are doing these days, and when have you seen A.J.? Had a real good time in Macon and wouldn't mind being there now as this town is some dull place. L.F."

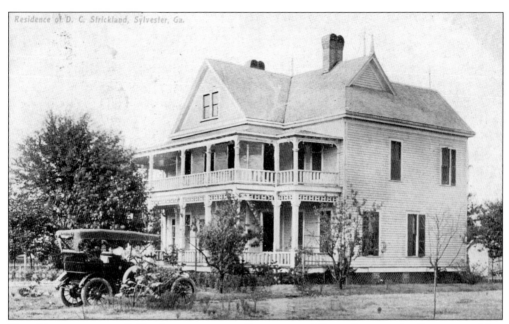

THE RESIDENCE OF D.C. STRICKLAND IN SYLVESTER. The writer was leading an exciting life as evidenced by this message mailed to a friend in Tallahassee on June 4, 1910: "Went to Cordele Thurs. & Albany yesterday. Going to Macon tomorrow & out to Atlanta to Bankers & C. of C. meetings. We go in Autos of course. Regards and write me. You and Jack be at Piedmont. May."

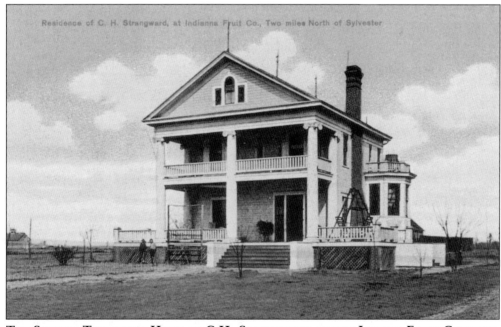

THE STATELY TWO-STORY HOME OF C.H. STRANGWARD AT THE INDIANA FRUIT COMPANY, 2 MILES NORTH OF SYLVESTER, c. 1910.

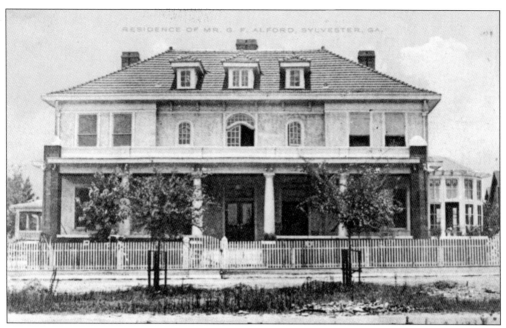

THE HOME OF G.F. ALFORD IN SYLVESTER.

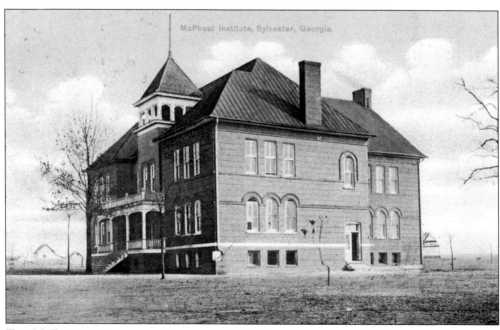

THE MCPHAUL INSTITUTE IN SYLVESTER, C. 1911.

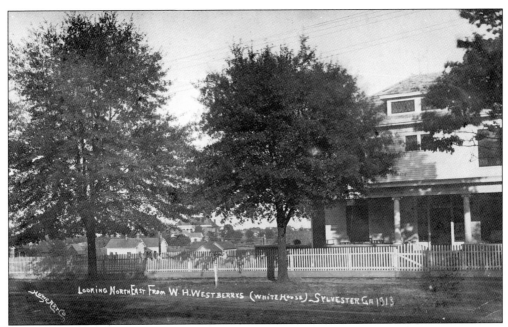

Looking NorthEast From W. H. Westberrys (White House) Sylvester Ga 1913

A REAL-PHOTO CARD. The handwritten caption on the front of the card says: "Looking northeast from W.H. Westberrys (white house) Sylvester GA 1913." The card was mailed to Live Oak, Florida, on June 24, 1914, with this message: "I take time for 30 minute 'snooze' after lunch each day, but am on the go the rest of the time. Alberta is looking fine. Mad because you did not go to train Saturday P.M. Be good 'til I see you. D.F.T."

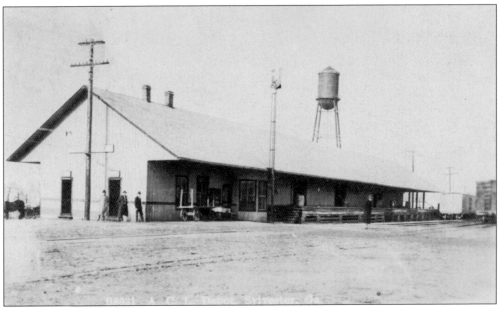

THE ATLANTIC COAST LINE RAILROAD DEPOT AT SYLVESTER, C. **1917.**

Five

DECATUR, GRADY, MILLER, AND SEMINOLE COUNTIES

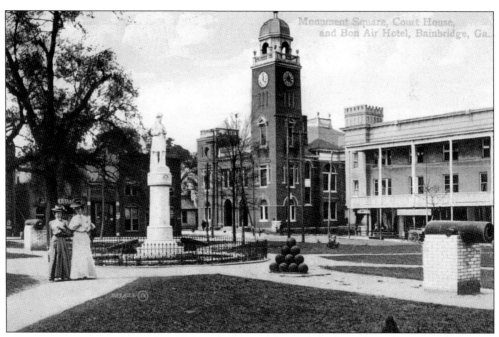

THE DECATUR COUNTY COURTHOUSE AT BAINBRIDGE. The courthouse was built in 1902 and remains in use. The Confederate Monument is somewhat unusual in that it remains in the original site where it was dedicated on Confederate Memorial Day, April 26, 1906. The monument stands in Willis Park, formerly called Monument Square, surrounded by a pool.

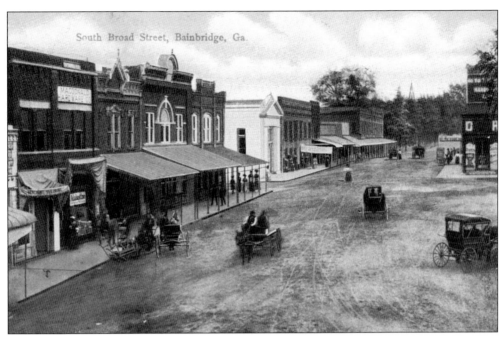

A NICE VIEW OF SOUTH BROAD STREET IN BAINBRIDGE ABOUT 1910.

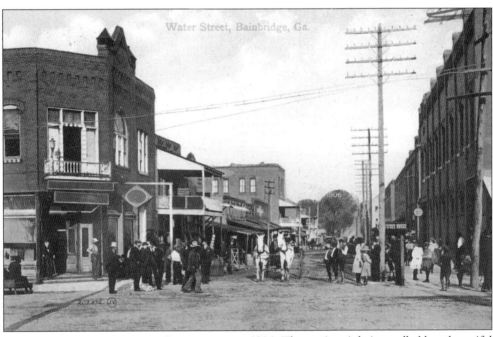

A VIEW OF WATER STREET IN BAINBRIDGE, C. 1906. The carriage is being pulled by a beautiful matched pair of white horses.

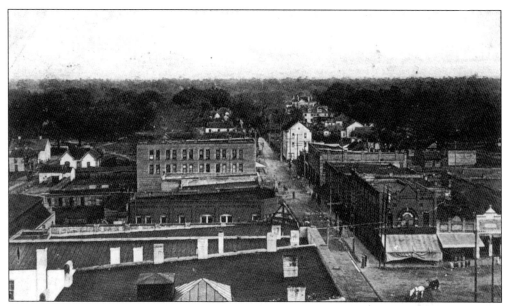

ANOTHER VIEW OF WATER STREET IN BAINBRIDGE, AS SEEN FROM THE COURTHOUSE.

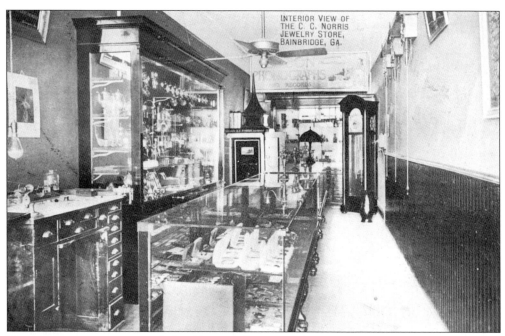

THE INTERIOR OF THE C.C. NORRIS JEWELRY STORE AT 325 WEST STREET IN BAINBRIDGE, C. 1910.

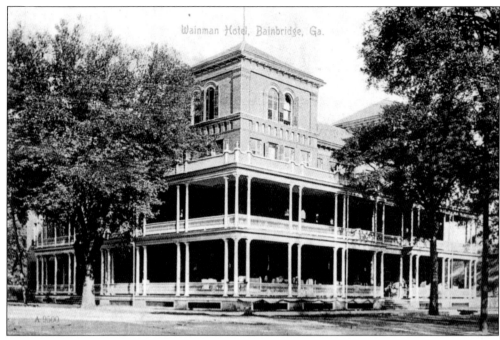

The Well-known Hotel Wainman in Bainbridge. In 1910 the hotel advertised steam heat, baths, and electric lights. The proprietor was George H. Fields and a room cost $2.50 per night and up.

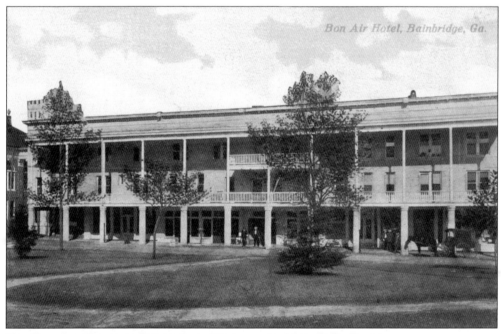

The Bon Air Hotel in Bainbridge, Managed by Mrs. B.D. Fudge.

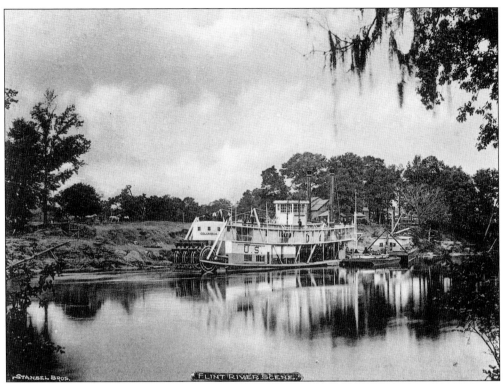

STEAMBOATS AND BARGES AT THE WHARF ON THE FLINT RIVER AT BAINBRIDGE, C. 1906.

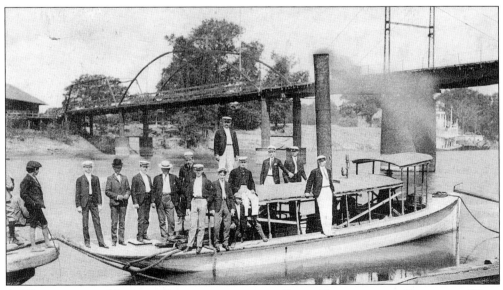

A VIEW OF THE MODERN BRIDGE ACROSS THE FLINT RIVER AND A PASSENGER BOAT IN 1905.

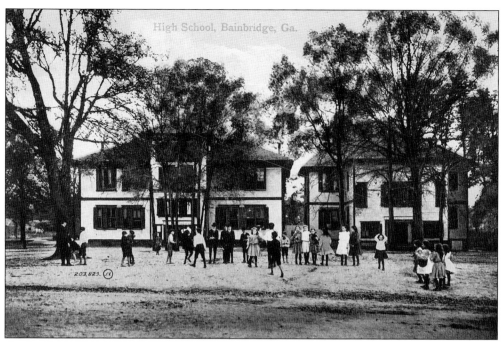

THE HIGH SCHOOL AT BAINBRIDGE ABOUT 1908.

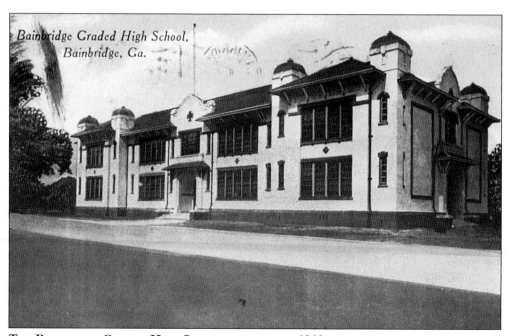

THE BAINBRIDGE GRADED HIGH SCHOOL IN THE LATE 1910s.

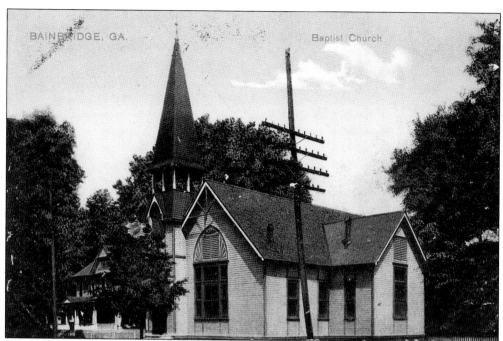

THE BAPTIST CHURCH IN BAINBRIDGE.

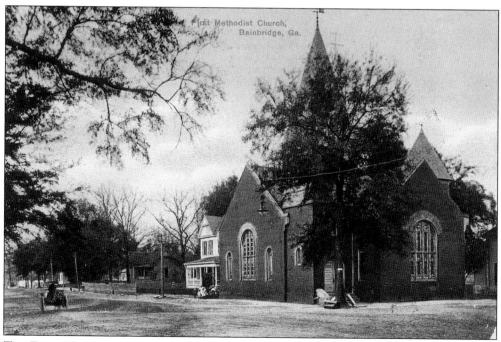

THE FIRST METHODIST CHURCH IN BAINBRIDGE.

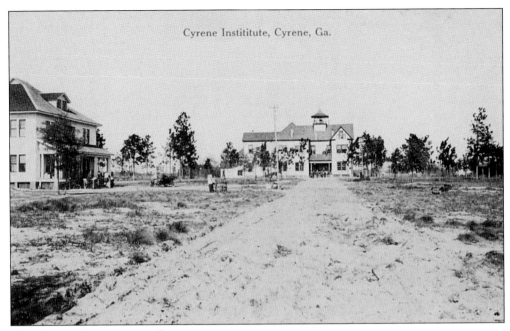

Cyrene Institute, Cyrene, Ga.

THE CYRENE INSTITUTE IN CYRENE.

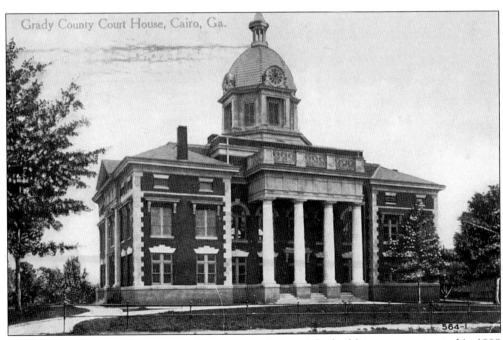

Grady County Court House, Cairo, Ga.

564-1

THE GRADY COUNTY COURTHOUSE BUILDING IN CAIRO. The building was constructed in 1908 and burned in 1980.

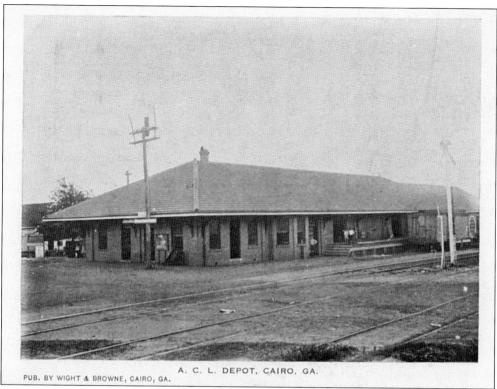

A. C. L. DEPOT, CAIRO, GA.

PUB. BY WIGHT & BROWNE, CAIRO, GA.

THE ATLANTIC COAST LINE RAILROAD IN CAIRO.

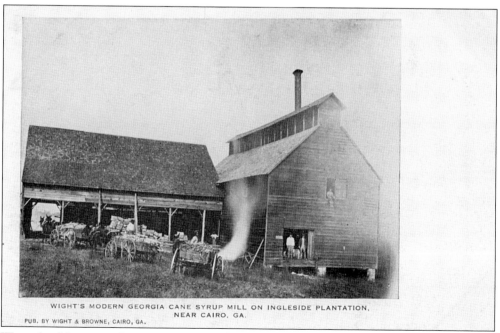

WIGHT'S MODERN GEORGIA CANE SYRUP MILL ON INGLESIDE PLANTATION,
NEAR CAIRO, GA.

PUB. BY WIGHT & BROWNE, CAIRO, GA.

WIGHT'S MODERN GEORGIA CANE SYRUP MILL ON INGLESIDE PLANTATION, NEAR
CAIRO, GEORGIA.

99

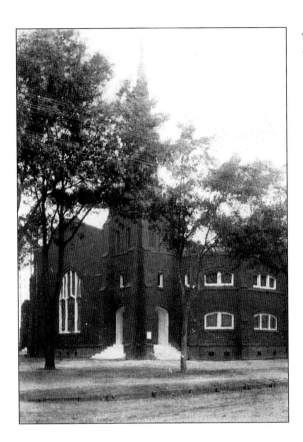

THE FIRST BAPTIST CHURCH AT
CAIRO IN 1908.

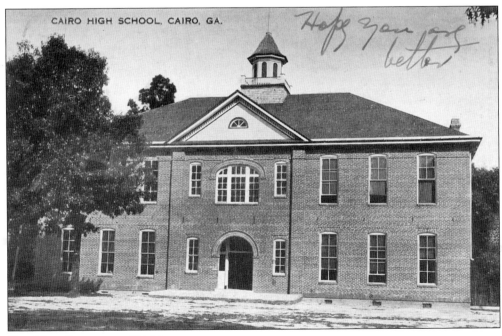

THE HIGH SCHOOL AT CAIRO.

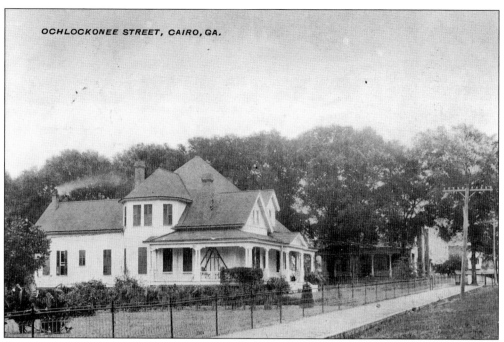

OCHLOCKONEE STREET, CAIRO, GA.

OCHLOCKONEE STREET IN CAIRO ABOUT 1910. This view shows some fine homes.

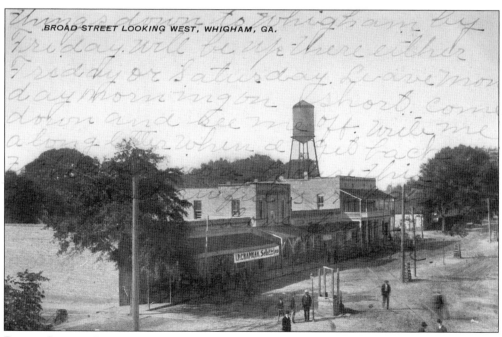

BROAD STREET LOOKING WEST, WHIGHAM, GA.

BROAD STREET, LOOKING WEST, IN WHIGHAM, *C.* 1910.

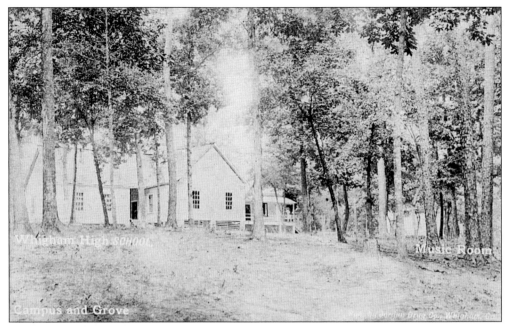

A View of Whigham High School, c. 1908.

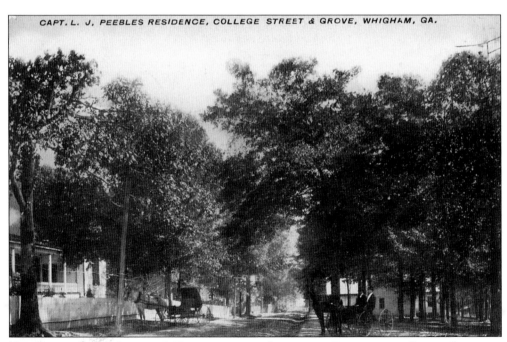

The Residence of Captain J. Peebles on the Corner of College and Grove Street in Whigham. The card was mailed to Milledgeville on October 29, 1910, with this message: "Dear Cuz, Guess you think that I am not going to answer your card but you see I am. I have had my hands full for sometime and especially this week as I have got me an Auto at last and am having a grand time. I am still at Whigham. Your cousin Harry."

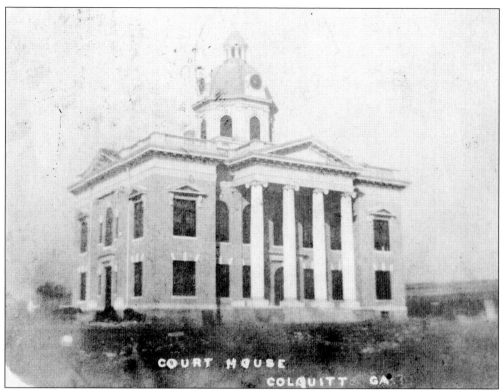

THE MILLER COUNTY COURTHOUSE BUILDING IN COLQUITT. The courthouse was built in 1906 at a cost of $20,227 and was destroyed by fire in 1974.

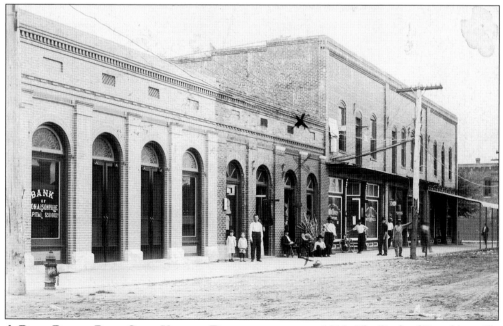

A REAL-PHOTO POST CARD VIEW OF DONALDSONVILLE IN 1912. The Bank of Donaldsonville can be seen on the left.

103

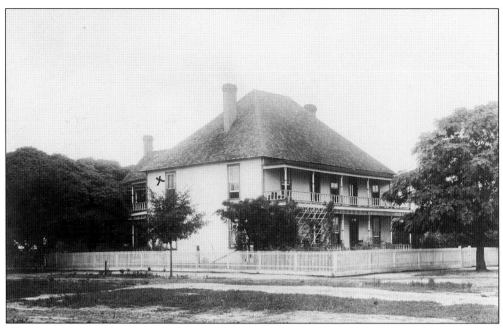

THE DONALDSONVILLE HOTEL, BUILT IN 1908 BY WILLIAM BISHOP KING.

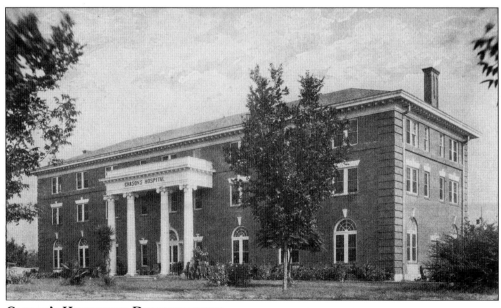

CHASON'S HOSPITAL IN DONALDSONVILLE.

Six

DOOLEY AND
SUMTER COUNTIES

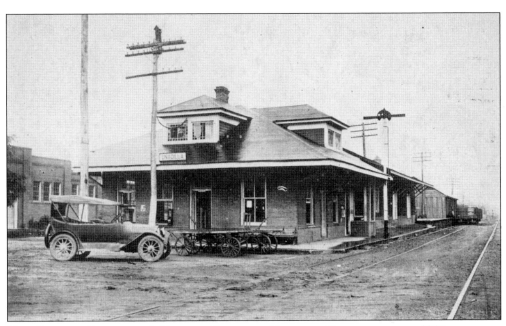

THE GEORGIA SOUTHERN & FLORIDA RAILROAD DEPOT IN UNADILLA ABOUT 1917.

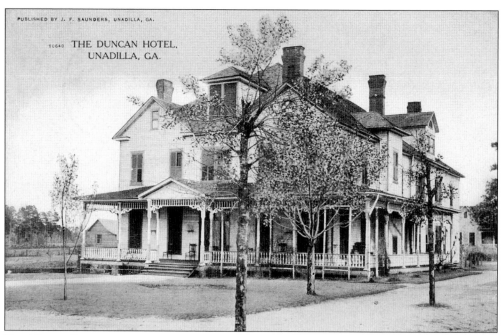

THE HOTEL DUNCAN, C.C. DUNCAN PROPRIETOR, IN UNADILLA, *C.* 1909.

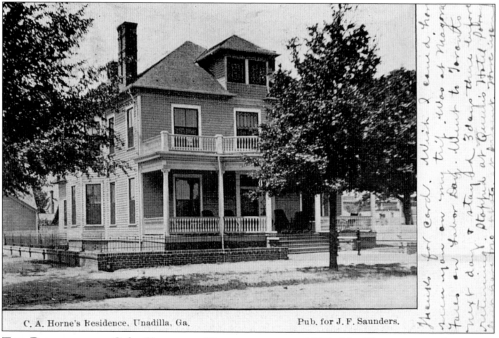

THE RESIDENCE OF C.A. HORNE IN UNADILLA ABOUT 1907. Mr. Horne operated a cotton warehouse and sold fertilizer.

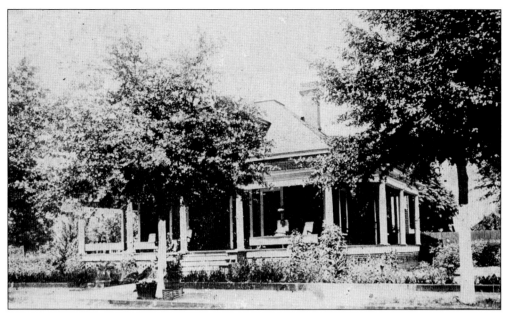

The Home of J.H. Dinkins in Unadilla, c. 1909.

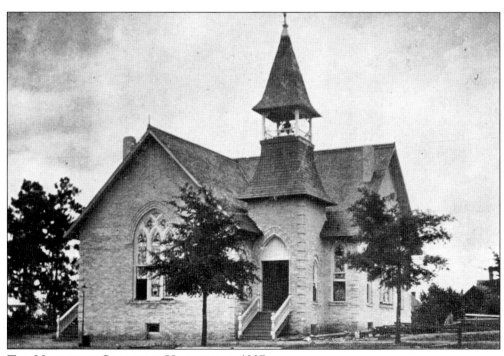

The Methodist Church in Unadilla, c. 1907.

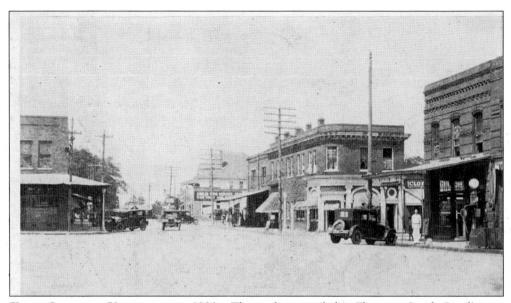

THIRD STREET IN VIENNA IN THE 1920s. The card was mailed in Florence, South Carolina, to Brooklyn, New York, with the following message: "This is the town we stayed in when in Ga. We are now up in S.Car. again to stay a couple of days. Start for home Friday A.M. expect to see you Sunday eve. L."

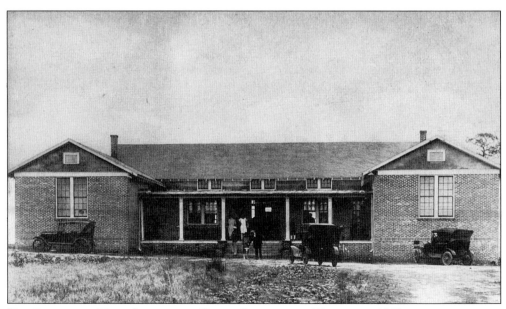

THE INDUSTRIAL HIGH SCHOOL FOR BLACK STUDENTS IN VIENNA, *c.* **1917.**

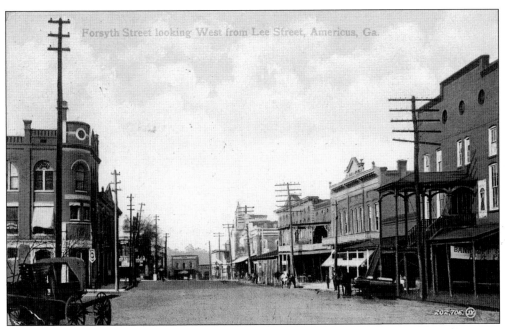

FORSYTH STREET, LOOKING WEST FROM LEE STREET IN AMERICUS, *c.* 1908.

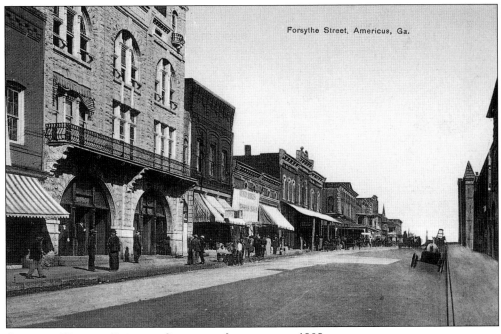

ANOTHER VIEW OF FORSYTH STREET IN AMERICUS, *c.* 1909.

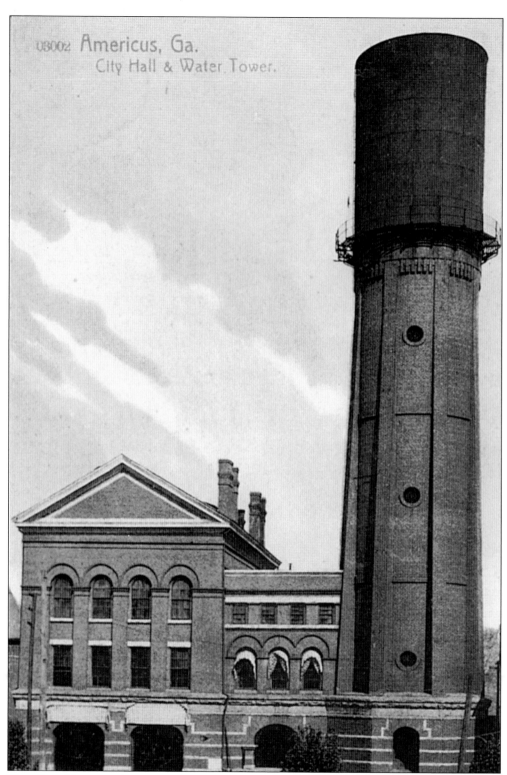

THE CITY HALL AND WATER TOWER IN AMERICUS, C. 1910.

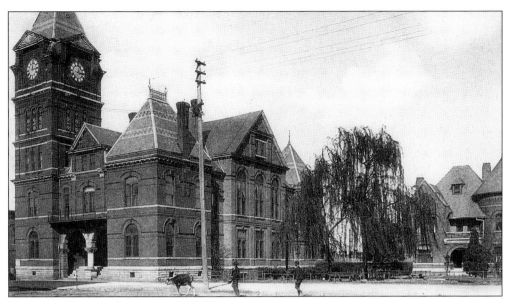

THE CITY HALL IN AMERICUS, *c.* **1905.**

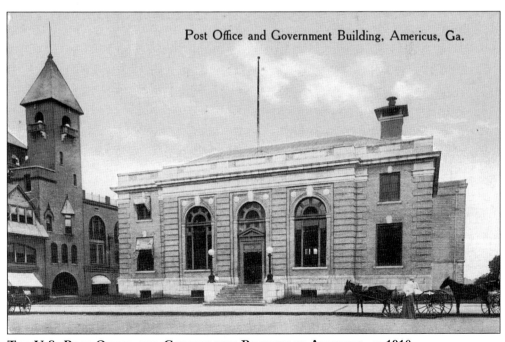

Post Office and Government Building, Americus, Ga.

THE U.S. POST OFFICE AND GOVERNMENT BUILDING IN AMERICUS, *c.* **1910.**

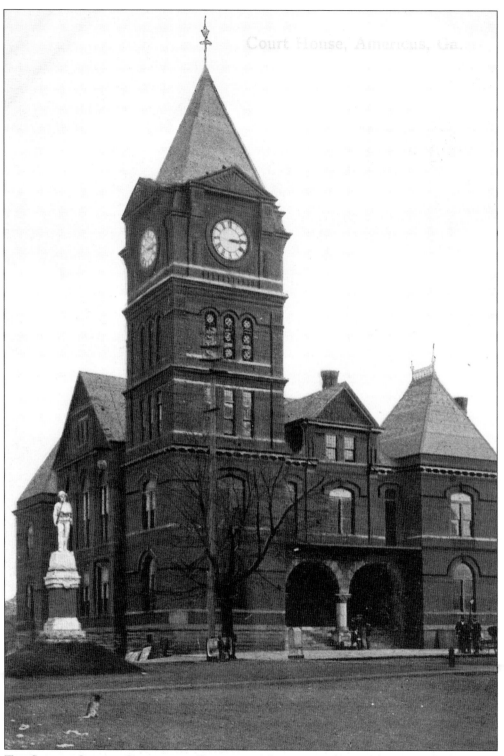

THE SUMTER COUNTY COURTHOUSE BUILDING IN AMERICUS. The courthouse was built in 1887 and used until 1959.

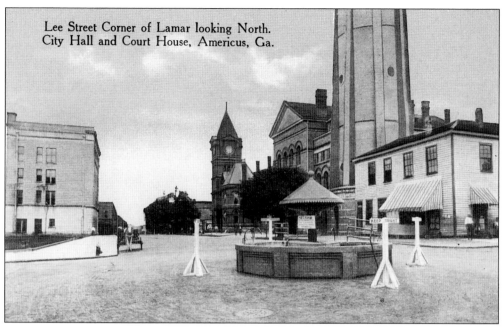

The Intersection of Lee and Lamar Streets, Looking North, in Americus, c. 1910.

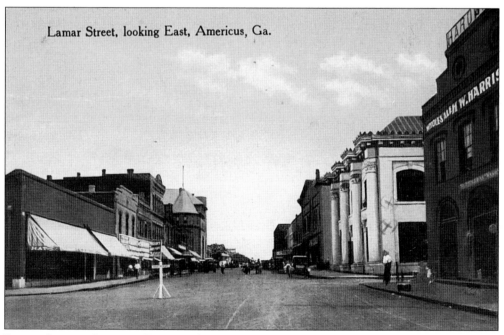

Lamar Street, Looking East, in Americus, c. 1912.

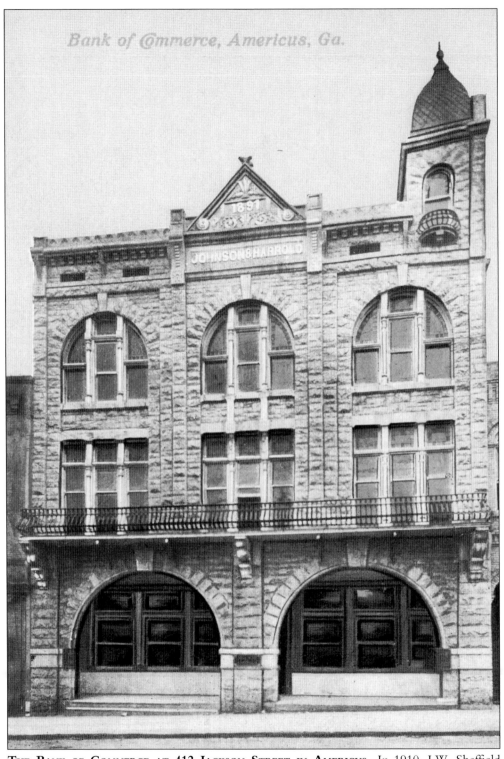

The Bank of Commerce at 412 Jackson Street in Americus. In 1910, J.W. Sheffield was president.

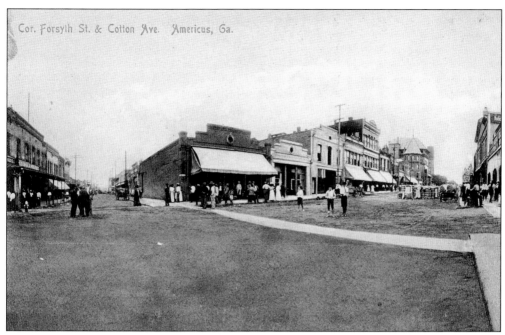

THE CORNER OF FORSYTH STREET AND COTTON AVENUE IN AMERICUS, *c.* 1909.

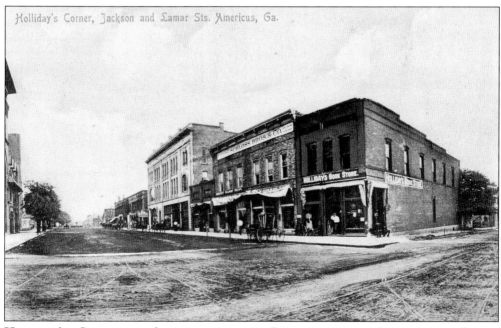

HOLLIDAY'S CORNER IN AMERICUS, AT THE INTERSECTION OF JACKSON AND LAMAR STREETS. Holliday's was a book and stationary store, shown here on the corner at 400 Lamar Street, *c.* 1909.

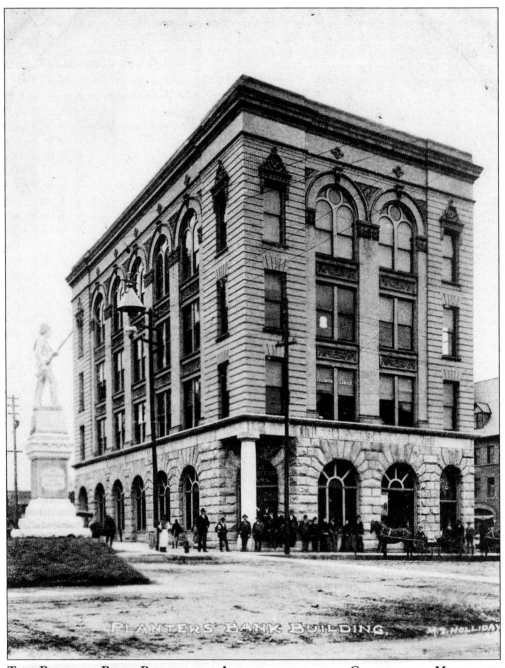

THE PLANTERS BANK BUILDING IN AMERICUS WITH THE CONFEDERATE MONUMENT, *C.* **1908.** The monument was erected at the intersection of Lee and Forsyth Streets in 1901 and was moved to Rees Park sometime after World War II.

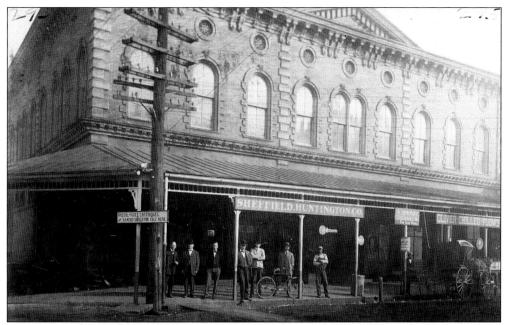

A Real-Photo Post Card View of Sheffield-Huntington Hardware at 201 Forsyth Street in Americus, c. 1907.

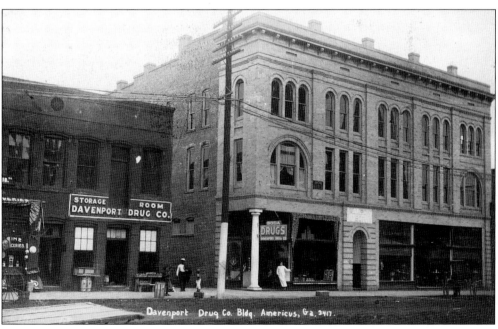

A Real-Photo Post Card View of the Davenport Drug Company at 410 Lamar Street in Americus, c. 1907. The drug store was operated by D.F. Davenport.

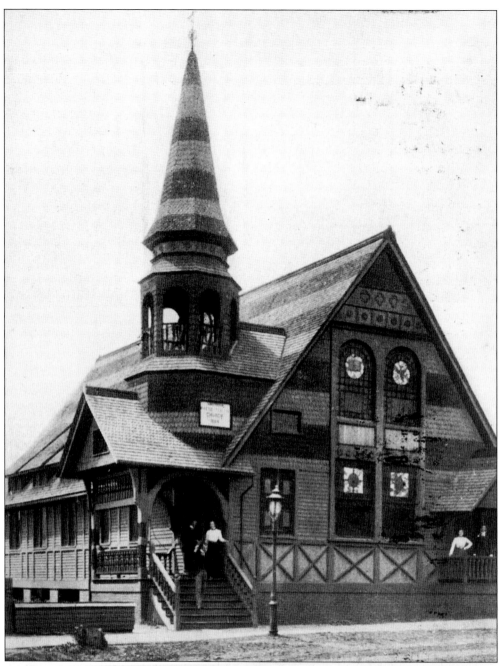

THE PRESBYTERIAN CHURCH IN AMERICUS, *c.* **1910.** The church was a beautiful, ornate wooden structure with a fancy steeple. The card was mailed to Versailles, Kentucky, on April 7, 1910, and the message contained the news that "This church is pastorless."

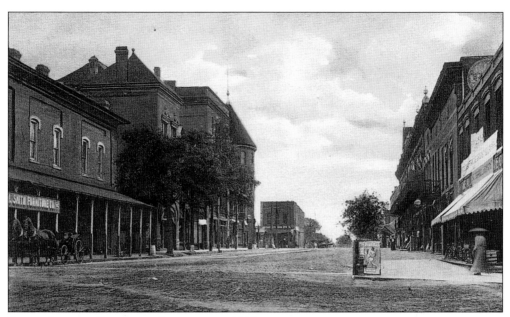

SOUTH JACKSON STREET IN AMERICUS, C. 1910.

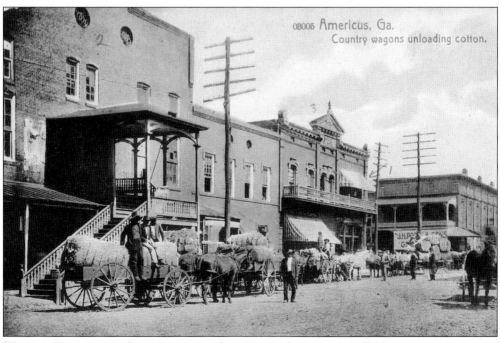

WAGONS FILLED WITH COTTON ON THE STREETS OF AMERICUS, C. 1910.

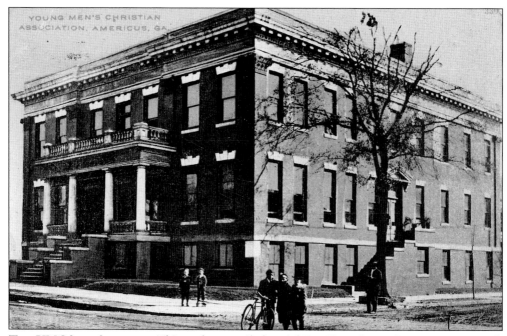

THE YMCA IN AMERICUS. This card was mailed to Athens, Georgia, on August 9, 1909, with this message: "Hello girls. Suppose you are tired out after your trip. I'm certainly enjoying my rest. Have been to several towns, have three more to visit before I return. M.C."

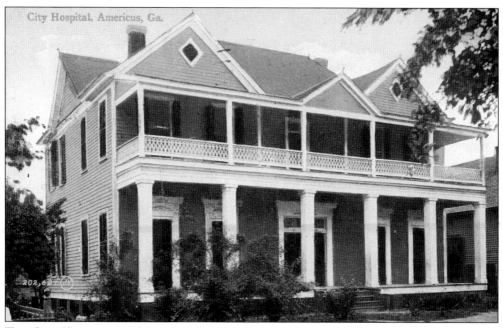

THE CITY HOSPITAL AT AMERICUS, *c.* **1912.**

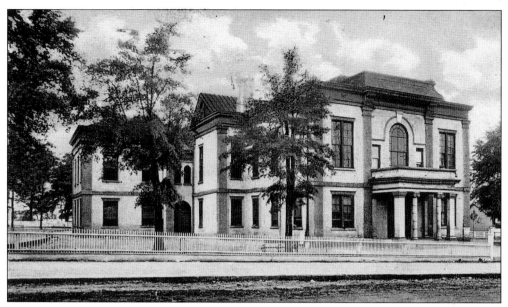

Furlow Public School in Americus, *c.* 1907.

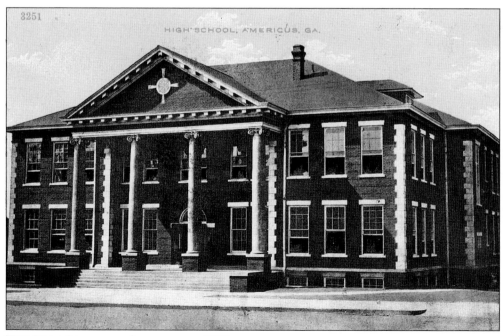

The High School in Americus, *c.* 1912.

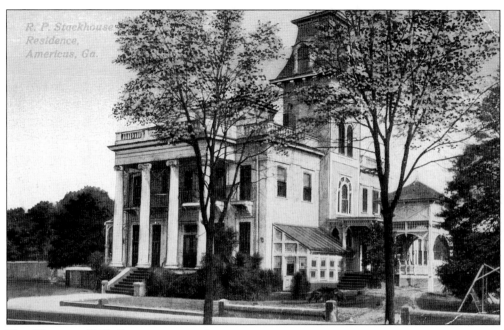

THE HOME OF R.P. STACKHOUSE IN AMERICUS.

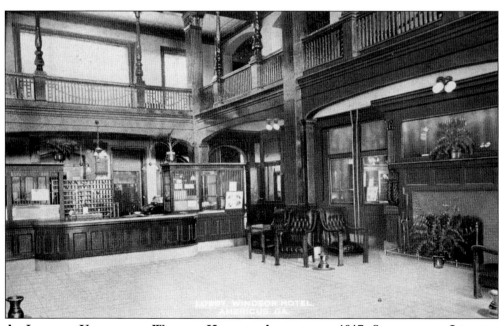

AN INTERIOR VIEW OF THE WINDSOR HOTEL IN AMERICUS, C. 1917, SHOWING THE LOBBY.

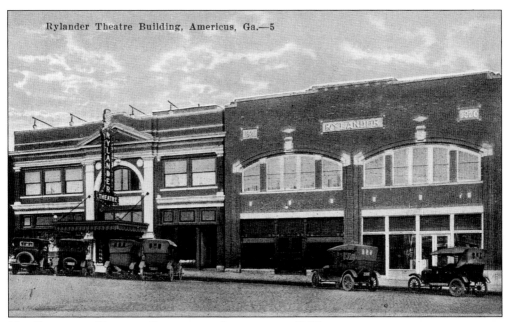

Rylander Theatre Building, Americus, Ga.—5

THE RYLANDER THEATRE BUILDING IN AMERICUS, *C.* 1917.

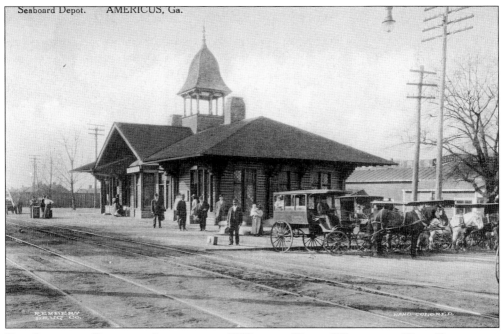

Seaboard Depot. AMERICUS, Ga.

THE SEABOARD DEPOT AT AMERICUS, *C.* 1912, WITH HACKS WAITING TO HAUL PASSENGERS TO THEIR DESTINATIONS IN TOWN.

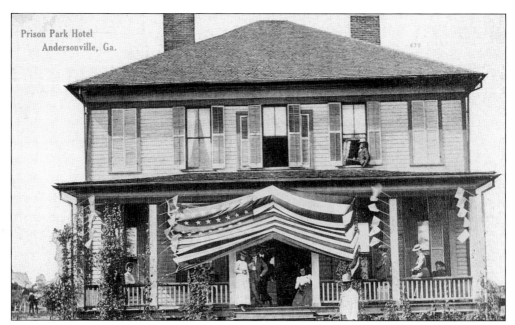

PRISON PARK HOTEL IN ANDERSONVILLE WITH LARGE AND SMALL U.S. FLAGS. The hotel may have been hosting old soldiers attending a reunion.

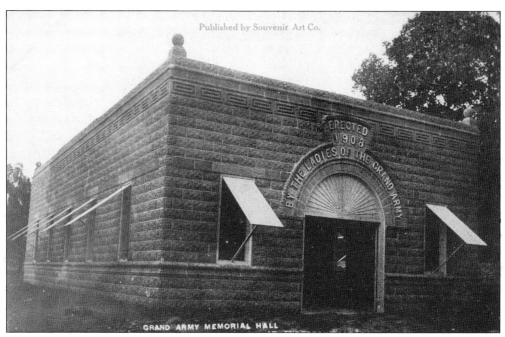

GRAND ARMY MEMORIAL HALL IN ANDERSONVILLE. The hall was erected in 1908 by the Ladies Auxiliary of the Grand Army of the Republic

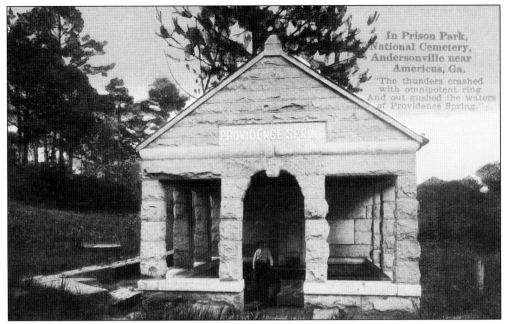

THE STONE MONUMENT BUILT OVER PROVIDENCE SPRING IN ANDERSONVILLE PRISON AFTER THE WAR BETWEEN THE STATES.

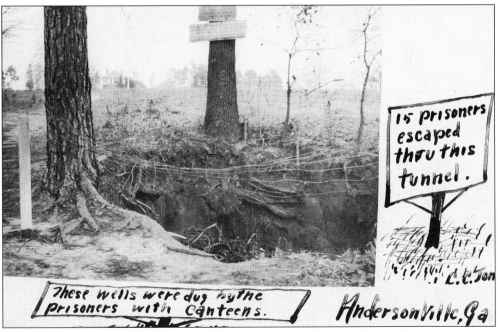

A REAL-PHOTO POST CARD VIEW OF A WELL AND ESCAPE TUNNEL DUG BY UNION PRISONERS AT ANDERSONVILLE PRISON DURING THE WAR BETWEEN THE STATES.

125

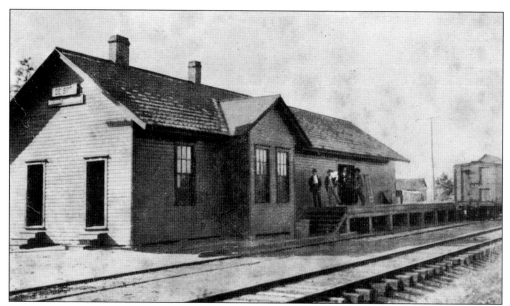

THE RAILROAD DEPOT AT DeSOTO.

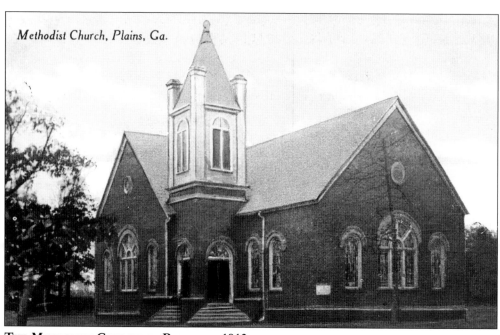

THE METHODIST CHURCH AT PLAINS, C. 1912.

BIBLIOGRAPHY

Anonymous. *1909-1910 Business and Professional Directory of the Cities and Towns of Georgia.* Atlanta, Georgia: Young and Company, 1910.

Jordan, Robert H. and J. Gregg Puster. *Courthouses in Georgia.* Editing and design by Patti Anderson and Mary Jackson. Norcross, Georgia: The Harrison Company, 1984.

Krackow, Kenneth K. *Georgia Place-Names.* Macon, Georgia: Winship Press, 1975.

McKenny, Frank M. *The Standing Army: History of Georgia's County Confederate Monuments.* Alpharetta, Georgia: W.H. Wolfe Associates, 1993.

Wen, Les R. *Ghost Towns and Depots of Georgia (1833–1933).* Chamblee, GA: Big Shanty Publishing Company, 1995.

INDEX